ART & SOUND

OF THE BRISTOL UNDERGROUND

BY CHRIS BURTON AND GARY THOMPSON

**First published in Great Britain in 2009
by Tangent Books**
Unit 5.16 Paintworks
Bristol BS4 3EH
T: 0117 972 0645
www.tangentbooks.co.uk
E: richard@tangentbooks.co.uk
Copyright © Tangent Books 2009
ISBN: 978-1-906477-06-6

Publisher: Richard Jones
richard@tangentbooks.co.uk
Design: Elly Grandison, www.grafix-studio.co.uk
Image editor: Martin Rogers
Additional design: Nick Law
Cover photograph and pages 68-74: Luke Quinn,
Inkie p30: Marc Hibbert; DJ Milo p89: Beezer

Printed and bound by HSW Print

A CIP catalogue record for this book is available
from the British Library

Thanks to
Krissy Kriss, Flynn, Paul Cleaves, Mark Cleaves,
Paul Smart, Rob Smith, DJ Milo, Paul Hassan,
Lewi, DJ Style, DJ Lynx, Zion, Ed Sargent, Felix
Braun, Joe Braun, Inkie, Nick Walker, John
Stapleton, Ian Dark, Chaos, Benjy Tonge, Justin
Britton, Stuart Rankin, Christian Geake, Manfred.

Tom Fewtrell (1973-2006 RIP), Alice Fewtrell,
Jasmine Main, Rodrigo Araya, Teresa Cole,
Michelle Araya, Hyacinth Burton, Merlita Burton,
Oli Timmins, Ben Millbank, Nicola Hurran, Grant
Marshall, Steve Pang, Jason Geake, Karen White,
Clive Rowe, Matt Legg, Mark Simmons, Richard
Mallett, Graeme (Grimm) Evlyn, Ian Sergeant,
Steve Wright, Bertel Martin, Dionne Johnson,
Ashley (Paramadic) Patterson, Lee (Leb) Bowden,
Matt Seaman, Lee Jordan, Leon Miller, Paul
Thorne, Marco D'Agnillo, Edson Burton, Shawn
(Napthali) Sobers, Rob Mitchell, Lekan Latinwo,
Kevin Philemon, Penny Delmon (Mammal Create),
Noel Flanagan, Rob Flanagan, Lindsay Hughes,
Simon Jutton, Joanne Peters, Sonia Cohen, Tasha
Ferguson, Maddy Probst, Natalie Mueller, Dylan
Ebutt, Joe Watkins, Julian Porter, Paul Bingham,
Dan Wemyss, Kerry Smith, Katherine Farquharson,
Kathy O'Brien, Kim Sargent (Tillett). B.J Denton,
R.G.Thompson, Carla l Green, R.Thompson,
J. Thompson, K. Thompson, Marc Hamilton,
Luke Quinn, John McNeilly, Caroline McNeilly,
Ben Thompson, Leanne Morris, Olivia Morris,
Isaac Thompson, Seb Thompson, Mark Parker,
Philip Mendez, Naoki: Miwako E-jima, Suv,
www.rue4.co.uk, Joe Burt, Lawrence Hoo, Tandy,
Carlton Romaine, Erin Bishop.

CONTENTS

FOREWORD

Yes indeed it's about that time, so do not, I repeat do not adjust your seatbelt as the new cycle is at hand and you're invited to experience a chapter taken from the 'Tales of the Brit side'.

To journey into the unknown Art and Sound of the Bristol Underground, this book is intended to capture, hold/bind you with the many other sides, opinions, points of view held by some and agreed with by many. So for the record; it's time to herald those who've captured hearts and minds, in times past, they'll last in shrines, savoured like wines, to give birth to prime designs. Transformed from pen to paper as the stakes got higher and enticed, like dice, the crews, with the art of the flyer.

Krissy Kriss, 2009

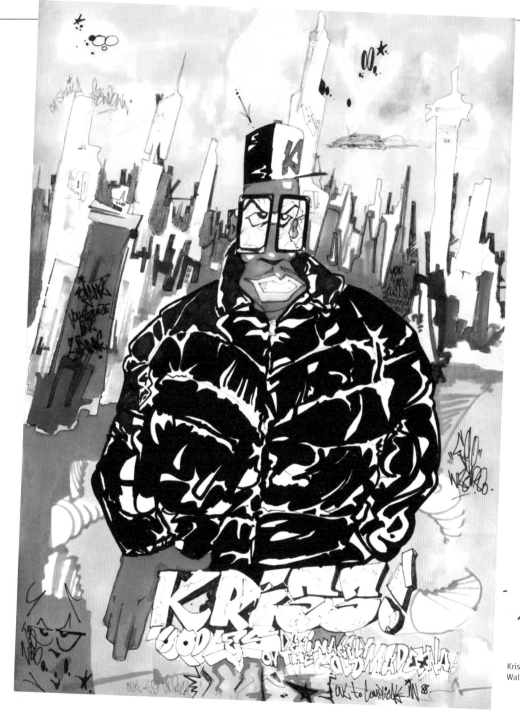

Krissy Kriss by Nick
Walker, 1988

IN THE MIX FOR '86

"While chatting about 'old times', going through tatty flyers and playing crusty old tapes in a machine called a 'tape deck' (if you were born later than 1988 you probably won't know what this is), we realised that we'd kept most of the flyers and tapes we had accumulated during our precious teenage years called The Eighties. This reminded us that this era was very special to us, and no doubt to others as well.

This book aims to look at the Bristol scene from a new perspective. The era being looked at is from the mid 1980s through to the early Nineties. Not only is this the era we remember best (too young to go to the Dug Out), but also this, from our point of view, is the era when the underground Bristol party scene was reaching its peak in around 1988/1989 – before all the 'random' house parties and illegal warehouse jams evolved into the more organised and more profitable 'raves'

and 'themed' club nights of the Nineties.

It is also a book about how Bristol has evolved socially and visually and how it has been regenerated. This book will look at the city as it was back then, it will delve into where these parties were and how they were promoted. It will be like a panoramic window into the past exploring the venues where these parties happened, where crews had their bases, where people hung out and where some of the freshest graffiti was at the time.

Many of these places have changed into something completely different or have been bulldozed. For example, there used to be all-night warehouse parties at Anchor Road warehouse, this is where @ Bristol and Millennium Square are now.

This was a time when most people from around our way and in this particular scene didn't really go to city centre clubs. We had our own parties in houses, squats, blues clubs, fields and warehouses. Bristol

was very different back then almost tribal and very zonal.

Another element that shaped the party scene was Pirate Radio. Stations such as Emergency 99.9 FM (which we have an account of in this book), B.A.D Radio, F.T.P and Raw FM played a huge part in giving platforms for DJs and MCs, promoting parties and developing this subculture. It would probably take another book to properly explore the role of pirate radio.

"There aint nothing out there for you man. Yeah there is... This!"

This book also covers many of the influences that got people into hip hop music, break dancing and graffiti. **Style Wars** and **Wild Style** in particular were influential underground films (if you weren't into the scene you probably wouldn't even have heard about them), and back then it was like a 'rite of passage' to watch them.

For us, and most people interviewed for this book, it seems that Bristol took the hip hop thing from New York in a different way to London, partly because of the size of the city and it being quite close knit. The inner-city areas of Bristol were very diverse in terms of race and class, so this mix of young people took the Bristol hip hop subculture in a slightly different direction.

This was a very vibrant time, and with the influence of the established 'Sound System' culture in this city, hip hop had an energetic and established underground scene from which to build. Hip hop was so fresh and new, everyone was trying to find his or her own identity within it. It was never about making money or even finding fame; we didn't even think about tomorrow much less the future, we were too wrapped up in the 'now' to think too far ahead. There are people who were into this scene from the early days but never played out or made a record, they just stayed as bedroom DJs and bedroom producers, some of them still do this, and they do it because they can't stop!

The images in the book are visually compelling but the real backbone of the book is all the stories and accounts from the people who helped put Bristol on the map through Art and Sounds. Without many of these people, the UK and beyond would be a blander place. All of the accounts are taken from interviews either across the Atlantic, through the internet, over the phone, in the street or just chatting over coffees, beers and other intoxicants reminiscing about old times.

These distant memories are from the mouths of the unsung heroes of the underground Bristol scene from that golden age, some of whom you may have heard of, some you may not know of. But you will find these stories, completely new or familiar, funny or sad and sometimes embarassing, but above all fascinating.

There is no doubt there are people not included in this book, some who we couldn't get hold of in time or just plain forgot to mention (sorry). There will be accounts that others remember differently or don't remember at all, but we have tried to be true to all the interviewees and all the people we've spoken to, but also true to the memories we have.

Chris Burton, Gary Thompson, Bristol, 2009

CRIMINAL JUSTICE ACT 1994

Our take on Sections 63, 64 & 65: Raves

A 'rave' is defined as a gathering of 100+ people, at which amplified music ('wholly or predominantly characterised by the emission of a succession of repetitive beats') is played which is likely to cause serious distress to the local community, in the open air and at night.

These sections give the police the power to order people to leave the land if they're believed to be preparing to hold a rave (2 or more people); waiting for a rave to start (10+); actually attending a rave (10+). Ignoring this direction, or returning to the land within the next week, are both offences, liable to 3 months' imprisonment and/or a £2,500 fine.

Section 65 lets any uniformed constable who believes a person is on their way to a rave within a 5-mile radius to stop them and direct them away from the area - failure to comply can lead to a maximum fine of £1000.

Sections 66 & 67: Seizure

The arrangements authorising police officers to enter land where
a rave is in progress or anticipated and which allow for the
seizure, retention and charges for the confiscation of vehicles
and sound equipment.

Section 68 & 69: Disruptive Trespassers

These refer to the new offence of 'aggravated trespass'.
Section 68 is committed by anyone trespassing on land in the
open air (not including highways and roads) with the intent of
intimidating other people engaged in 'lawful activity' on that
land or adjoining land, so as to deter them, or obstructing/
disrupting them ('lawful activities' of course include such
delights as fox-hunting; earth-raping etc etc...)

Section 69 gives the police sort of preventative powers to
direct people to leave land. This direction can be made by a
senior officer as long as at least one person is committing
or intends to commit aggravated trespass, or there are two or
more people present with the 'common purpose' of aggravated
trespass.

Failure to comply with this direction carries a maximum
penalty of 3 months in prison and/or a £2,500 fine.

2BAD CREW

1983 - 1989

ED SARGENT
DOM T

One of the original Bristol DJ Crews, whose collection of tunes and mixing skills sets them aside from most. With regular DJs spots at legendary clubs such as the Dug Out and the Moon Club, 2Bad influenced many other DJs

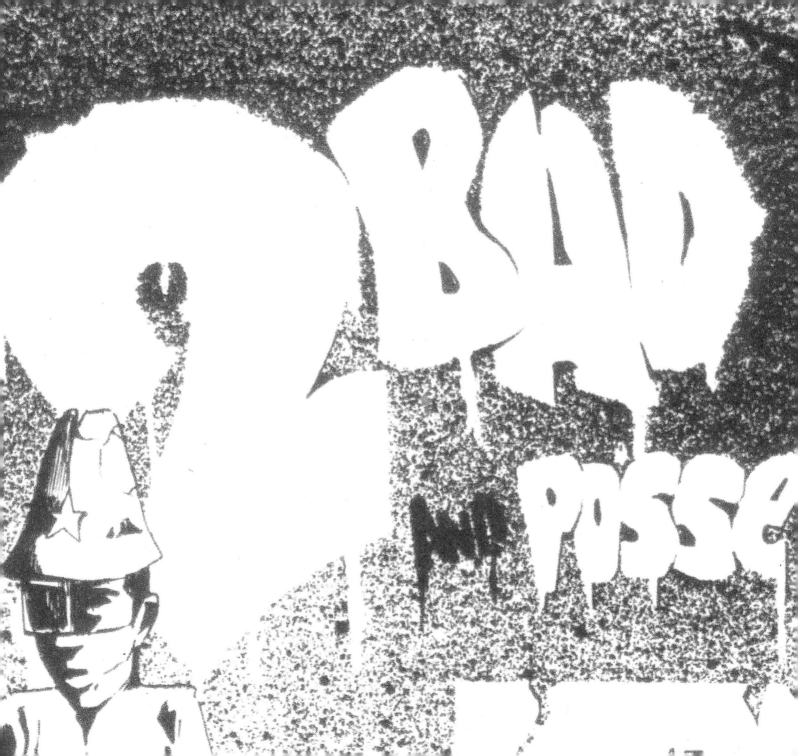

ED SARGENT

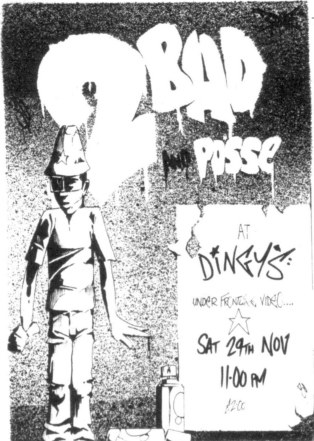

" I've always taken music seriously and DJing was something I fell into. Grant, Kosta, Nellee and I used to do the occasional party using my system and Kosta's car – Nellee and Grant used to DJ. Eventually they formed the Wild Bunch and that's when I decided to do my own thing. Around the same time I was working in The Friary Café where I managed to save enough to buy 2 LADs which were cheap versions of the Technics turntables. With the help of some of the girls (Zoe Warren and Teresa Cole) lending us their tunes, Dominic Thrupp [Dom T] and I started to do our own parties. All kinds of music interested me but mainly reggae, funk and soul. I guess 2Bad ended when I moved to the States in 1989.

Bristol, as well as the people I hung out with, had a big influence on my musical interest. Though I would say we were fairly insular at that time. When I think back now yes, Bristol in this era was special, everything was fresh and exciting and there were some great DJs and rappers although I don't think we realised

"Bristol, as well as the people I hung out with, had a big influence on my musical interest"

that at the time. I definitely think the social mix of Bristol played a huge part in the early party scene. There were no-go areas in Bristol but in general everybody hung with everybody. I got on really well

with most of the guys from the other crews to the extent that I used to play them our new tunes, which used to piss off Dom because everybody was conscious of other people biting their tunes. The only time we battled other crews was at the Train Station, Temple Meads (Brunel Shed) where 2Bad threw down with the Wild Bunch and kicked ass! Milo wouldn't talk to us for a month.

We used to love our regular night at the Dug Out as well as our regular night at the Moon Club where we used to double up the sound system. In terms of other people's parties, Wild Bunch at the Dug Out was always a great night.

London and New York didn't really play a role in my development, apart from listening to KISS FM tapes out of New York. Those guys [Flash, Marley Marl and Hashim] were all great artists, but the first time Grand Master Flash played in Bristol, I was at Trinity Hall watching Tappa Zukie. Regarding the graffiti scene in the US compared to the UK, I would say in those days the US were streets ahead. But it was exciting to see the start of the British graffiti scene, I saw D [3D] do some of his first ones. The design of flyers was a very important part of the whole package. Luckily for me and Dom we always had some great

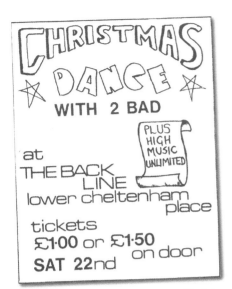

CHRISTMAS DANCE
★ ★
WITH 2 BAD
PLUS HIGH MUSIC UNLIMITED
at THE BACK LINE
lower cheltenham place
tickets £1·00 or £1·50 on door
SAT 22nd

PARTY!
COME TO TERESA & JULIUS'
'SUIT PARTY!' SAT 5TH NOV.
IN 'THE FRIARY' Cotham Hill
10 til late ~ SMART DRESS ~
★ Bring a bottle ★

#PEACE PROMO 88
OLD SCHOOL
ROCKIN THE HOUSE
DOM T 2 BAD DADDY G
26th NOVEMBER £2·50 ENTRY
THE THEKLA

Page 11 and left: 2Bad Posse at Dingys by 3D, 1986

Above: 2Bad Christmas Party at Backline

Right: Party at the Friary Cafe, Cotham and the flyer for Dom T, Daddy G at the Thekla by Nick Walker, 1988

Above right: Dom T (left) and Ed Sargent at a 2Bad & KC Rock party at Dingys, 1986

artists who wanted to do them for us, including 3D for one.

I've only been to Bristol for two weeks in 20 years so wouldn't know about the scene in the UK at the moment. I'm not involved in the industry any more, I'm a 'chippy' and I do the occasional set and party where I play reggae, mainly rock steady – my first love. ✖

CHAOS
1983 - 1989 ARTIST

Chaos was a graffiti artist who was all about putting it up on walls. Hailing from south Bristol, he hung out with and did flyers for Fresh 4. Chaos prefers graffiti when it had more of an edge and it was a lot more illegal

CHAOS

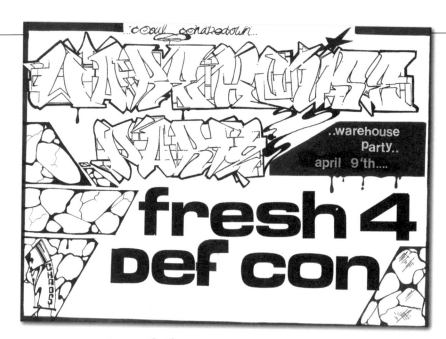

> Yeah I did a few flyers back in the day but it was more about going out and painting on walls. I did flyers for Fresh 4 because I used to go to all their parties and used to knock about with them, I'm from Knowle West as well and I used to hang around with Tricky too. I was into 2tone and punk back then, which was the new thing before hip hop took hold. I used to go to Heroes, a 2tone shop on Fairfax Street where you got all the gear. Milo worked at Paradise Garage opposite the old Replay Records shop which was like 'the' punk shop. I mean punk was a thing a lot of people were into before hip hop and I think a lot of the Bristol hip hop scene was influenced by punk.

I used to come over to central Bristol to party because I was hanging around with the Fresh 4 guys and we went to a lot of places like The Domino Club, the Moon Club, the blues clubs, the house parties and all that. The Moon Club had a period in about 1987 or 88 when it seemed every weekend and even weekdays too, it was just rockin' down there. There weren't many places we would go to regularly apart from this except places like the Domino Club, Studios, Freeze and the

"I think a lot of the Bristol hip hop scene was influenced by punk"

Mayfair Rooms, but they weren't as regular. It's really hard to remember details because we were going out every night and it just seemed to go on for ever.

I got into graffiti in about 1983/84 when I saw the book **Subway Art** and pieces by 3D that were going up around Bristol at that time. There was a piece by 3D on the old Virgin record store on Halifax Street that said 'Wild Bunch' that was wicked, also stuff by Nick Walker – one of the original artists from Bristol. The exhibition at the Arnolfini was a big influence too

because there was nothing like it before. I do think those days were special because it was so new and we were teenagers just growing up and discovering new ways to express ourselves. But I didn't think graffiti would be as big as it is now and influence so many things. I think it died out in the late 80s, the B-boy element died at this point and rave came along which I wasn't really into. So I started to listen to reggae and stuff like Jah Shaka and went backwards in terms of music.

I think towards the late 80s was the Bristol peak in terms of parties and clubs and there were people like Soul II Soul and of course Wild Bunch/Massive Attack who were starting to make an impact internationally. The party I remember most was Wild Bunch and Newtrament, but the

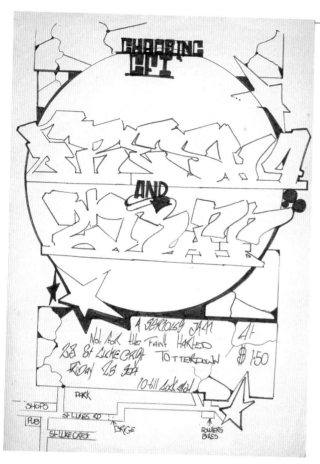

I heard about when the Wild Bunch first went to New York and were hanging out with the Fearless Four. They couldn't believe Wild Bunch were playing hip hop or that there was a hip hop scene in the UK. When they came over to play with Wild Bunch they were blown away at how hip hop had taken off in the UK. That's how early Wild Bunch were in it – early hip hop was still totally underground and new.

The Fresh 4 parties in St Luke's Road were wild as well, the venue was a squat and it was a rough place, I mean a lot of parties back then were held in abandoned houses and warehouses and stuff, but the venue didn't really matter as long as it was big enough. I remember when Fresh 4 broke into an old cinema and got a generator going and many other parties getting raided by the police. We were always in trouble though; we were just teenagers growing up. The vibe at these parties was different to how it is now, there wasn't as many people sniffing coke, dropping pills or smoking crack, it was more of a weed and beer thing. But I think that just reflects society as a whole anyway.

I don't do graffiti any more, I lost the feel for it, but back then I was crazy into it, I used to paint with Inkie sometimes too, and I remember getting arrested painting trains. I remember when 3D, Inkie and Goldie were bringing people like T Kid, Vulcan, Brim and Bio over to Bristol to do graffiti, but now I think it's lost its edge and become more acceptable to society. I mean all the elements that make up hip hop, dj-ing, graff, everything has become mainstream. For me it was more a rebellious thing, trying to get yourself out there, it was a lot more illegal too. I think modern Bristol has moved away from this and taken a different turn, but when I'm in New York it's still a bit like 'Style Wars' it's still got that edge it's like a time warp, even in the some of the subways. I still have a love and appreciation for it and I always will, it's like a heritage for me and it developed at a crucial time in my teenage years when influences make you who and what you are today. ✖

best thing I remember from that era was Wild Bunch at St Paul's Carnival on Campbell Street. It was like a reggae 'sound system' thing, the Bristol scene took their lead from that which was already here in the city and just took it to a different level and a new audience. I remember 3D, Pride and Inkie doing a piece on the wall at the top of Campbell Street at Carnival while the Wild Bunch were pumping out tunes.

Page 15: St Luke's Road Warehouse Party Fresh 4 and Def Con by Chaos

Far left: Warehouse Party Fresh 4 and Def Con by Chaos

Left: Fresh 4 and 2Tuff by Chaos

CITY
ROCKAS
1983 - 1988

City Rockas were one of the original B-boy crews and could always be found strutting their stuff at many hip hop jams in the early days. When they started to DJ they specialised in classic funk

LEWI
DIZZY T
DONOVAN

CITY
ROCKAS

LEWI

> I started buying hip hop tunes and I had hip hop tapes because I was 'poppin' in around 1983. We just grabbed the moment. Hip hop was so fresh at the time. It started when a brother called Joe Black came back from New York – this must have been 1981 or 1982. He showed us this dance he brought back and he called it 'Pop lockin', this other guy Oscar was doing it too and when I saw it I was hooked, I just went away and practised till I got my own style.

There were three of us in the crew; Me, Dizzy T and Donovan. Donovan and Dizzy are brothers and I'm their cousin so it's a family thing. We used to go to Revolver Records to buy tunes where we met Daddy G and that's how I got to know the Wild Bunch. We went to all their jams to break dance and body pop. I remember going to London with the Wild Bunch in the very early days to dance. They were having a battle against The World Class Wreckin Crew (Dr Dre's original electro crew) in an old amphitheatre in London and they more than held their own. Dre had a guitar and played their latest tune, Wild Bunch came back at them with one of their killer dubplates and the place went crazy!

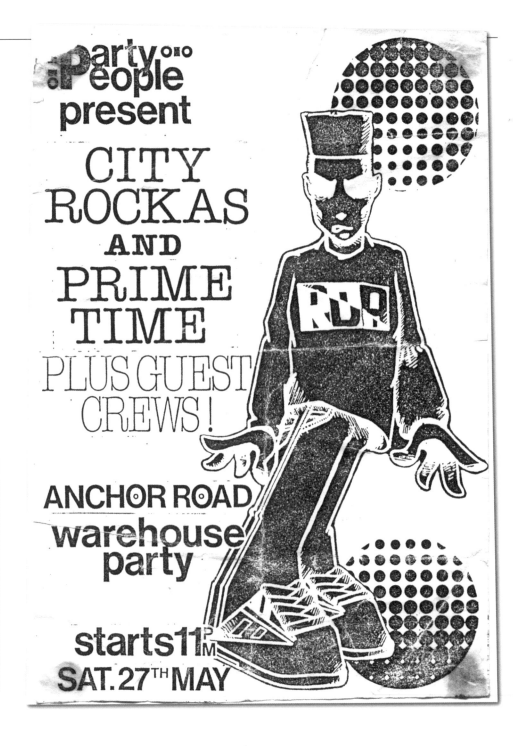

We used to go round Grant's house, and there were always people there just chilling, listening to music and smoking weed. We met a lot of people and became friends from hanging out there. I mean, I still know people without knowing their names just from being at the same parties back then. For me at the time, DJ Milo and Nellee were the best DJs in Bristol possibly the UK, but there was also another DJ called General from UD4. He was dangerous, his scratching was technical and his 'transformer' scratch was crazy! There was always competition between UD4 and Wild Bunch, because they thought they were 'badder' than anyone else. It didn't turn violent or anything because it was 'sound bwoy business', who had the baddest tunes!

When it came to tunes Milo was the man; his collection was just so diverse he would play obscure old funk and breaks that no one had ever heard before, and when the mood took him he would be on the decks for hours. At about this time Donovan was buying funk tunes by Kleeer, The Jammers, and Steve Arrington when they were released. We weren't in competition with anyone in Bristol really, we didn't play tunes that Wild Bunch were playing. In the very early Bristol DJ scene Galaxy Crew and Wild Bunch were the only ones playing funk and breaks, most other sound systems played reggae. To

"General from UD4 was dangerous... his transformer scratch was crazy"

me Wild Bunch, Galaxy Crew and 2Bad were the founders. Even though we were going to London and having burn-offs with other crews we didn't think hip hop or being a DJ was a career move, we didn't think it would be as big as it is today. We were into it because we loved it and it was underground. I mean, it's overtaken rock music as the biggest selling musical genre.

My favourite party that we did was our first in 1984 at the Mayfair Rooms. This was a posh place in them days; I mean, they had carpet on the floor! It was £600 to hire (which was a lot of money) I was so worried that we couldn't fill the place and couldn't pay the £600! But everyone got dressed up and rammed the place out. I remember Dizzy T played **Intimate Connection** by Kleeer and even though it is a slow tune, it rocked the house! When Dom T and Nellee came up to us after and said 'wicked party' it spurred us on to do more! But there were a lot of fights at our parties between possees from different areas. Many of these people had their own personal beef with each other and just brought it to our parties which

made it really hard to keep it going. In the end we just stopped as it got too much.

Bristol was funny back then, I mean, we would never really travel outside of central areas really. We always thought of South Bristol as being racist, there was no reason to go there. The outskirts of Bristol (and even some central parts) were really racist then – skinheads who really wanted to kill you or do some serious damage would literally chase you down. We did go to few Fresh 4 parties down there but not many. The best party we ever went to was Wild Bunch at the Redhouse; this was just a disused warehouse on Portland Square. It was one of those nights words can't justify. It was just crazy!

To me Bristol was and always will be special, we always thought that if you're good at what you do then it doesn't matter where you come from. Most people I knew back then who were doing music or just into the scene are still doing music and into that scene. As for City Rockas, we don't really play out together but we haven't broken up, we all still do music in some shape or form. I play bass in a band called Laid Blak. ✖

CRIME INC

1983 – PRESENT

Working side-by-side with the DJ crews, FLX, Inkie, Jinx and Nick Walker formed the Crime Inc Crew and brought the art form of the New York underground to the new Bristol scene

FLX / INKIE / JINX / NICK WALKER

FLX

1984 - present
Crime Inc Crew (CIC)
FBI
Real Deal Artists (RDA)

" Doing graffiti and the whole hip hop thing was kind of rebellious, it was a reason for people to get together and forget their differences. I think the size of the city, the fact people were relatively close together, also made Bristol's vibe back then what it was. From as far west as Clifton to as far east as Easton and south touching Knowle and Bedminster there was a small kind of corridor through the centre of the city – you could walk from one side to the other in less than an hour. So there was this thing that people were overlapping because of the geography. School also played a part in this because people from different areas met each other through it.

Other parts of the country had similar histories, like Camden where my cousins grew up. In the 1980s it was very multicultural and that's where Soul II Soul kind of came out of. I went to college in Birmingham and that also had a scene of students living in the poorer areas going to the 'Blues' and underground clubs. You get those kinds of bohemian things going on, I mean, you got that in New York in the late 70s and early 80s and that is the fuel that makes these kinds of subcultures happen.

There were a lot of different groups of young people in Bristol at the time who had their identities like jitters, mods etc, but punks and their music was a kind of fusion of a lot of different ideas. A lot of these original punk guys started to cross over to more of a soul, reggae and funk based sound and that's what The Pop Group and Rip Rig and Panic grew out of. My first memory of this was at the Dug Out club where we would sometimes go on a school night. And that thing about different music getting played side by side... I didn't know anything else; I just assumed that was what all parties were like. There wasn't a real pattern to these parties; there would be some hip hop, some breaks and then some house music later on.

The venues, or should I say lack of venues, had a lot to do with the underground Bristol party scene back then. There weren't any big clubs that were catering for that particular taste in music so it all was borne out of necessity, out of a need for something that wasn't being provided at the time. There wasn't really anything else to do, if you weren't dressed in the right way or didn't look old enough you wouldn't get into a club in the centre (not that you'd want to go anyway). Apart from going to Wild Bunch at the Granary on Saturday afternoons for under-21s, I didn't ever go to town centre clubs. There was Tiffany's, which was at the top of Blackboy Hill where the BUPA Hospital is now. It had an under-13s night on a Wednesday and an under-16s night on a Thursday playing Gap Band, Kool & the Gang, Freeze and that type of stuff. So it had to be a total 'D.I.Y' way of doing it. I mean, we begged borrowed or stole; the guys who gave us the PA did the bar or the security and took their cut from that. The venues for the parties were usually free – house parties, abandoned houses or squats and warehouses. So all this made the parties more intimate and people got to know each other who probably would never have talked to each other outside of the scene. People just seemed more relaxed in these venues.

Wild Bunch and Newtrament at Redhouse was a party I was at but don't remember much of because I was drinking Tennants Super and smoking copious amounts of spliff. I fell down some stairs and lay on the floor and these girls just had to step over me. All I remember was that there was wicked graffiti there but this was really early on for me and one of my first parties. Jason Geake (Wise Guise) took me to that night. Wild Bunch had it locked down already; they were one step

ahead of the game. They had Poppers, Breakdancers and B-boys there, together with DJs and MCs. They also had Pride and Zaki Dee from the original Chrome Angels painting with 3D. That had a massive influence on me, even if I did end the night being carried home.

It was a lot easier to do back then too, it was pre-Criminal Justice Bill and the fact that nobody had done these types of parties on this scale meant that the police didn't really know what to do about it. Even though the Bill was more to stop 'acid house' warehouse parties that were starting to take over, it also killed the original house party thing. It actually all became too big to be sustained in this way, warehouse parties survived by turning into more organised and profitable 'raves' and that was that.

Bristol people grew up going to festivals; Glastonbury was like a borough of Bristol in the 8os. I first went to Glastonbury in the early 70s when I was a little kid. So just hearing a rumour of a party going on in a field just outside of Bristol got people trudging from all over

"They had Poppers, Breakdancers and B-boys there, with DJs and MCs…"

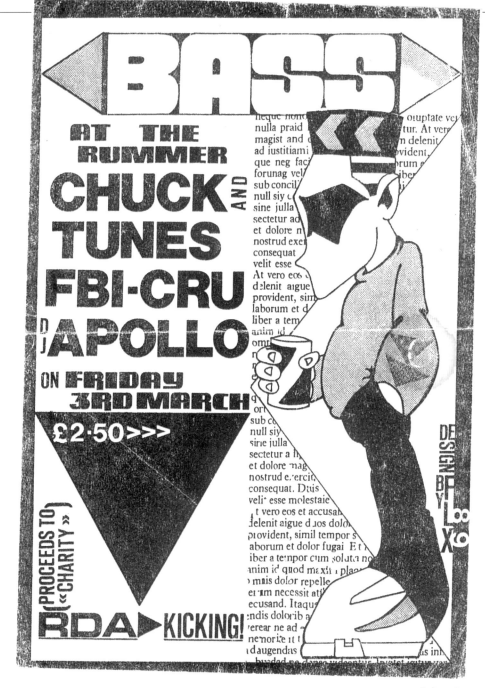

the place to get there, I think we just loved to party.

We got to know FBI through a mutual friend who sold draw and had a pool table in his house. We met them there, chilled out, smoked spliffs and listened to tapes, Tony Humphries, Kiss Fm and that. We just got talking to them and it seemed a natural progression, Wild Bunch had 3D, and they [FBI] wanted some visual stuff to go with what they were doing, we were impressed because they were doing what Wild Bunch were doing and they liked what we were doing. I went to school with Paul Cleaves but he left quite young and I was a bit wary of him and his brother Mark. We started to do flyers for them around late 1985 or 1986; in fact in 1986 we had Crime Inc/ FBI black and pink T-shirts printed by Neil Young at Seebright printers on Stokes Croft that Inkie had designed.

When jams started to move more into clubs. I remember FBI at Tropic with KC Rock – Krissy Kriss, Claudio, Rob, Wallace, Rookie (R.I.P) and then with UD4. Doing flyers for FBI was a good thing for us; it got our graff out there to people who would not otherwise see it. Remember this was pre-Internet and mobile phones so this was like the 'grapevine' for us, people would hear about us through seeing our flyers.

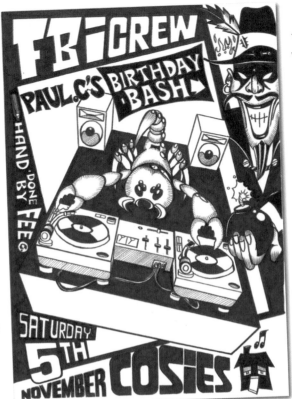

"The whole buzz was knowing you were part of something..."

Looking back to those days Bristol was special, but at the time we didn't think that because we didn't know anything else, we thought this was how it was supposed to be. Obviously, it felt magical but we were just teenagers in the middle of growing up experimenting and experiencing new things, and we wanted

to copy New York. We wanted to emulate what we'd seen in **Style Wars**, **Wild Style** and the graffiti bible **Subway Art**, and in mimicking it we helped to create this scene. Of course it was unique. It's created some very individual and inspirational talent that has gone on to form a big part of the backbone of popular culture in Britain, through the 1990s and up to the present day.

Just speaking for myself and my immediate group of friends, we were into graffiti and hip hop and we wanted to hear the soundtrack to that. And if that meant hearing a rumour that Wild Bunch were playing at the top of Campbell Street on a Saturday afternoon two weeks before Carnival 1986 or 1987 then we would be there. Those were the special moments. The whole buzz was knowing you were part of something; whether it was doing flyers for parties, painting on boards in parties or being pissed out of our heads stumbling around at warehouse parties tagging anything that wasn't dancing; that was us.

The first piece I ever put up was 'Stink' with my brother Jinx and Inkie, it was behind the University library in Clifton right near the classic 'Phase II' piece by 3D. We didn't have any emulsion we just painted onto raw brick. That was Halloween 1984. I had always been into

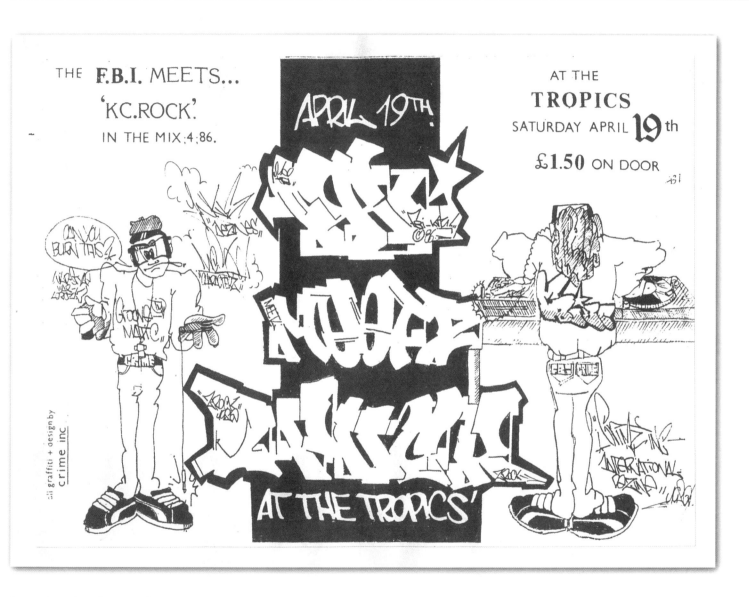

Page 23: House of Yeyo by Inkie, 1992

Left: Paul C's Birthday Bash 'hand done' by FLX

Page 28: House Party by Inkie and FLX (CIC)

Page 25: Party at the Rummer by FLX (RDA), 1989

Above: FBI meets KC Rock by Inkie and FLX (CIC), 1986

Page 29: Kick That Bass FBI Crew by FLX (CIC)

drawing ever since I could hold a felt tip pen and I was also into comic books – Marvel, DC and 2000 AD, it was something that you escape into. While my brother Jinx and Inkie were spraying outside my mum and dad's house I would be upstairs drawing and trying to perfect this art, I was a real perfectionist and probably still am. I got into graffiti because of seeing **Wild Style** at the Arts Centre Cinema with pieces by 3D and Z Boys in the hallway. There were other little bits that influenced me too; like seeing Dondi in the **Buffalo**

"I got into graffiti because of seeing Wild Style at the Arts Centre Cinema"

Gals video putting an outline on a letter with one huge sweep of the arm in a shop window on Fifth Avenue, New York.

Then we did a piece at Cotham School. Me, Jinx, Inkie and Nick Walker did the piece on the girls' gym in early 1986 all in Buntlack. We went back over two

consecutive weekends. The first time we just put up this piece that said 'Drastic' which Inkie had designed and the second time we went back we had shit loads of Buntlack – I think it was the paint we had left over from doing the Filton College common room or it could've been after one of our thieving trips down to Euro Graphics on Temple Way. It was the biggest piece done in Bristol at the time, which ended up reading: 'The Drastic Adventures Of Crime Inc', it was a whole sentence, this represented like a 'whole car' to us. I mean there weren't many trains to paint in Bristol so this was really special to us. It had a really 'trippy' multi-colour scheme and to be fair the whole Buntlack colour scheme was really nice anyway so we couldn't go wrong.

We didn't really battle anyone because we were confident in our own ability and were at the top of our game. When we started to paint walls hard 3D and the Z Boys had stopped painting illegally. So we were the only crew in Bristol putting graff up on a regular basis. The only other person we were aware of was Nick Walker, who we knew through mutual friends of ours that were in his year at school and we also used to hang out with him at Special K's.

The process of making flyers wasn't instantaneous, it was a combination of hand-drawn and Letraset rub-down letters

and it took ages, especially if you didn't want to see the lines where you cut round the edges. It was all photocopied by hand, I mean it was a total labour of love and it shows in some of them. It helped fuel the anticipation for the night. Hooking up with FBI was a chance for me to get into the musical side of it, we were not just at the parties dancing or doing graff, we were part of making the night happen that was the difference. We were totally immersed in the consumption and production. It was at critical time when we became teenagers. I was 13 when I saw **Wild Style** – it was this whole new concept fully formed. I just feel lucky to have been that age at that time.

My favourite flyer that we did was KC Rock and FBI at the Tropic club. My favourite flyer by someone else must be one of the early ones by 3D, they were just stunning. There was just something about seeing them that was like alchemy! How the fuck did he do that?

We didn't think about the future, we were too wrapped up in the now to think too far ahead. We didn't think beyond next week or our next £3 draw! We didn't even think bigger, better, faster, if it was the same next time it was good enough, it had its own rhythm and it was what it was. The drugs were different back then, too, so that set the tone for a lot of the vibes. It wasn't amphetamine or chemical

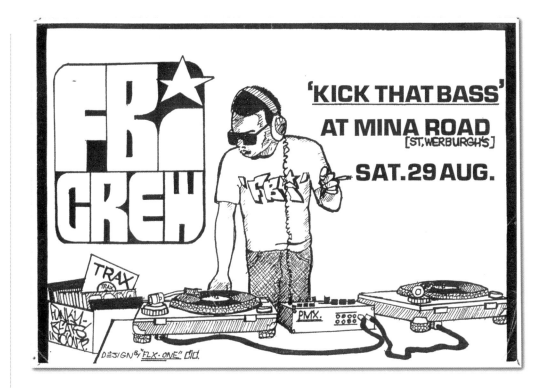

stimulant fuelled, it was a ganja and beer-fuelled subculture. Of course there was speed and acid trips you'd get from the bikers, and sometimes mushrooms when they were in season, but this wasn't all the time and it was usually fairly mellow, it wasn't aggressive, it was about having a fun time in the moment.

I think the modern graffiti scene is great and it's nice that someone like me can make a living through painting and teaching kids to paint. It has become so much a part of modern popular culture that I'm proud I was there at the

beginning. I don't go out and put stuff up on walls illegally any more, but I still get a buzz from seeing it and have admiration and respect for anyone who does it now.

As a teenager that's what defined me, I was a graffiti writer first then everything else after. I still define myself now as a graffiti artist and a writer but also as a teacher. I also still love making music. Really I'm a renaissance man; I can't limit myself to one thing. ✖

INKIE

1983 - present
Crime Inc Crew (CIC)
Real Deal Artists (RDA)
The Ultimate Artists (TUA)
Ninjas of Tag
Original Gods of Graffiti

> I was always into art, especially comics like 2000 AD, and I used to draw logos and all the different characters from Sam Slade and Judge Dread. I used to collect comics and I've still got a big collection. People like Ian Gibson and Carlos Esquare, Rick Leonardi from Marvel comics, John Byrne and Sicovic got me into graphics and lettering. There was this English guy who did a comic called Captain Britain I can't remember his name but his stuff was amazing, he also did stuff for 2000 AD.

In 1983 I was into punk and bands, we used to paint the names and logos of bands on our school rucksacks. When the films **Style Wars** and **Wild Style** came out, Felix and Joe [FLX and Jinx] had a copy of **Subway Art**, I went round their house one night and when I saw the book, it just blew my mind. Then literally the next day we got some spray cans and went out painting.

The first piece I ever did was with Joe [Jinx] in his back garden, it said 'ID'. The first 'Inkie' design I ever did was in 1984 and I've still got it. We did some Inkie 'throw ups' in Redland and the first Crime Inc Crew piece was 'Stink' with FLX and Jinx near the University building next to the classic 'Phase II' piece by 3D. We did another piece there a bit later called 'Feel the Force'. We also did the massive 'Drastic Adventures of the Crime Inc Crew' piece on the wall of the gym in Cotham School with Nick Walker a bit later. We did loads of pieces around Cotham in those days. I remember when a few friends of ours died in a car crash over the Avon Gorge we did a memorial piece for them at the Dean Lane skate park.

The first crew I was in was the Crime Inc Crew with FLX and Jinx, I was also in a crews called TUA [The Ultimate Artists] with Fade and Jaffa; Ninjas Of Tag with Nick Walker and Criss Cross and Original Gods Of Graffiti with Nick Walker and 3D. We [Inkie, FLX and Jinx] did an arts project in St Paul's with Fade and Style [DJ Style] under the name Real Deal Artists. Then later I started hanging out and doing graff with John Nation and the Barton Hill lot.

3D's graffiti going up in Bristol was a major thing that turned me on to it, but there was also this guy called Tarzan and no one knew who he was. I remember he did a wicked piece on the boards on

Station Road in Montpelier, he was a big influence. At one point all of the boards were covered with graffiti all the way up that road leading to the archway where the Montpelier pub used to be. There was no internet, so the only time we saw this stuff was when we saw 3D's stuff in Bristol and when we used to go to London to buy comics and trainers we would get a glimpse of it there. In London it was the Chrome Angels, Pride, Mode 2, Scribbler, and Zaki. There were others like Scam and Eskimo, who were all a big influence. We were also in touch with Goldie and Desire in Birmingham; they used to come down to Bristol. We brought Brim & Bio down to Bristol in 1985 or 86; I mean, we had a lot of the New York artists at the time coming to the city. Bristol was like a home of graffiti at the time. I was hanging out with the Barton Hill guys when Vulcan and those guys came over from the US in 1989 when me and Cheo came second in the world graffiti championships.

My favourite piece that we did was 'Knowledge' in St Paul's; the lettering was so sharp it would still stand up to graffiti

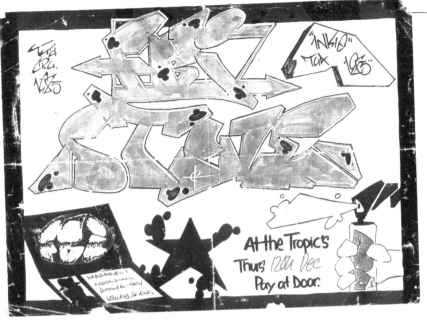

"They tried to shut me down but I carried on just without putting 'Inkie' on anything I did"

today. I also really like the one I did in Moss Side when we were on this police bail thing up in Manchester. The piece I really like that we didn't do was that old one at the bottom of Park Street that 3D did. I also really like the King piece in Boyce's Avenue in Clifton, this was with Pride when they had this thing called The Union when the Chrome Angels were in Bristol and hooked up with 3D. There was even a crew called the Trans-Atlantic Federation – 3D and Goldie with Brim & Bio.

I got nicked four times and then we got 'that' bust [the huge Opertion Anderson police operation] and they put me in the frame as the ringleader. They were right on my case. I was away when they raided my house and got 10 bin liners full of 'evidence'. They tried to shut me down but I carried on just without putting 'Inkie' on anything I did. It ended up with it getting thrown out of court because basically the 'evidence' was shit even though they had me 'bang to rights' they couldn't prove it in a court of law. The hand writing experts said you couldn't prove anything done from a spray can. But they all knew it was me and some of them even said to me 'off the record' that they loved the stuff but were under pressure to stop it. That killed the Bristol scene for a few years, then you had guys like Banksy, Sickboy and Dicey come along on the second wave and re-ignite the scene a bit. I got right back into it again with him [Banksy] and now we've got like a third wave happening.

We never thought it was going to be this big, even if you'd told me four or five years ago I wouldn't' have believed you.

I never thought people would take it seriously enough. Even some of the stuff they call street art now is fucking rubbish really. Back in the day we'd take four or five hours putting a piece up illegally and now someone can come along with a stencil and put something up in five minutes, it's ridiculous. But don't get me wrong if it's good I'll like it, it's just the rubbish stuff people are calling great is what I can't understand.

We were closely affiliated with FBI Crew through hanging out at Spellbound amusement arcade and the Friary Cafe. I knew Paul Cleaves and Phil Jones who went to my junior school, that's who I did my first flyer for, but I also did flyers for the Plus One/Sweet Beat Jam in 1986 and I did some early stuff with 3D for the Wild Bunch flyers. I used to paint at Wild Bunch parties as well. I've still got the flyer for the Wild Bunch/Newtrament Rock Box party in London, it was the 21st September 1985, my 15th birthday and I went up there with them on a big tour bus from Bristol. I tagged up there as well. We used to try and tag as many places as possible but when we did flyers we realised they were like having 500 tags. This was pre-internet and pre-mobile phones so this was like advertising for us. People who never met us could know about us through flyers. We got a lot of our reputation through our flyers. Nobody

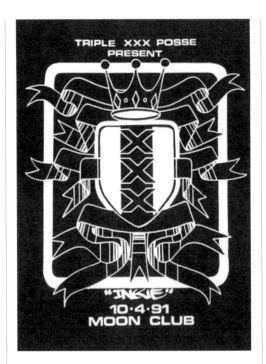

does flyers like that anymore.

I always loved the house parties, they were the best. Phil Jones' party was a favourite, FBI also did house parties in St Paul's with Dennis Murray [Dirty Den/Easy Groove] and I remember stuff in St Andrew's with UD4. Then they [FBI] went on to do nightclubs like Hollywood's, Tropics and the Moon Club. But to be true, house parties was where it's at you know. It was like everyone was trying to out do each other with parties, if you did a wicked party you would get respect and the stuff FBI and those guys were doing took it to a different level.

"Back in the day we'd take four or five hours putting a piece up illegally..."

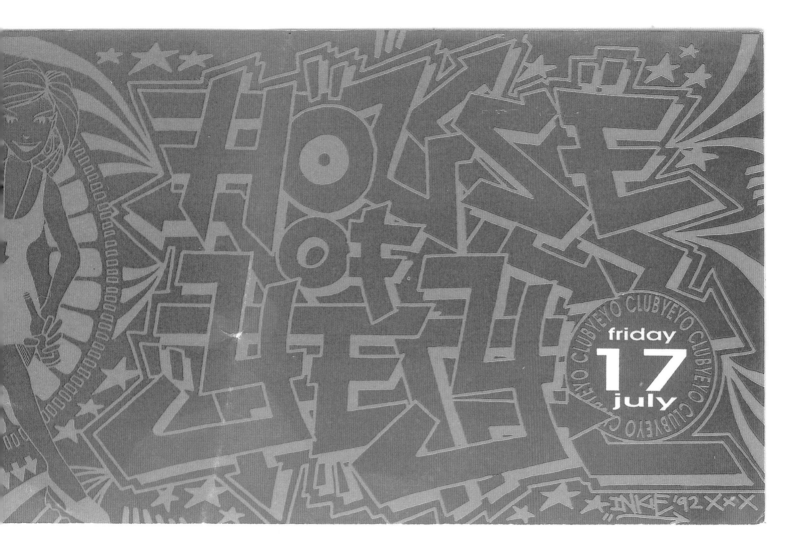

House of Yeyo by Inkie, 1992

friday 17 july

CLUBYEYO CLUBYEYO CLUBYEYO CLUBYEYO CLUBYEYO

★ INKIE '92 XXX

Page 30: Inkie photo by Marc Hibbert

Page: 31: FBI Style at Tropics, one of the first designs for FBI by Inkie (TUA), 1985

Page 32: Triple XXX presents at the Moon Club by Inkie, 1991

Above: House of Yeyo by Inkie, 1992

I remember Kingsdown Festival when Paul Smart [FBI] and Sui were breaking and popping up there, that's probably my first jam. I remember breaking burn offs at Cotham school in the very early days as well. This was when we were school kids and we weren't going to clubs because we couldn't get in. There was also this thing down at Dean Lane skate park in Bedminster where they had the decks in the band stand.

I still do graffiti in the original form, I still go out 'piecing'. I do more illustrative

"I still do graffiti in the orginal form, I still go out piecing"

stuff these days, but for myself I always do a bit of the old 'wild style'. I've still got the buzz for it. It's one of those things, the more I see the more I want to do, it's also that competitive streak, if I see something that I think is good I still want to go out and prove I'm better, I never settle for second best. The whole

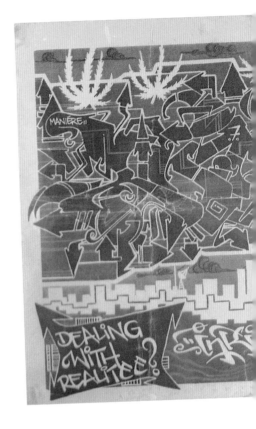

graffiti culture is about showboating really; it's about shoving it in people's faces. Nowadays you can use graphics and computers but for us it was always about the drawing.

Without Bristol I wouldn't be doing this, Bristol was like the adopted home of graffiti. If you look at it and then think who are the top 50 graffiti artists in the world, half of them would be from there. In Bristol we had a small community of

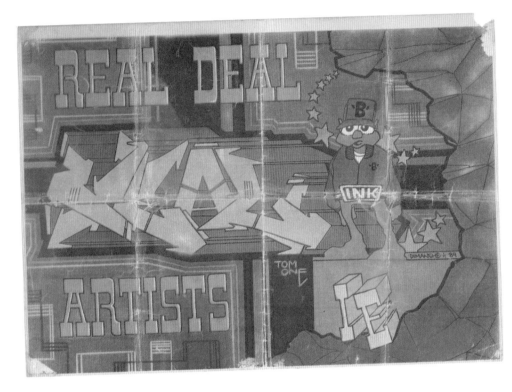

artists who were in healthy competition with each other. This was different from places like London and Birmingham which were so big and divided up into areas where most people there didn't contact each other as much as in Bristol.

Before, I was working full time to pay for my hobby and now my hobby has taken over my work, I always wanted to be an artist and never for money, but now all that hard graft I put in is paying off. I will always be a graffiti artist first but I'm also an artist. Graffiti taught me typography skills, but I'm always expanding my scope and learning new skills and disciplines.

Joe was the ideas guy and me and Felix were the one ones who put it together technically and we all went out and put it up together so it was a good little unit. And don't worry we're gonna be bringing the Crime Inc Crew back real soon… ✖

Far left: Freehand by Inkie, 1989

Above left: Dealing with Realitee. Club Dimanche freehand by Inkie, 1989

Above: Real Deal Artists. Club Dimanche freehand by Inkie, 1989

JINX
1984 - 1990
Crime Inc Crew (CIC)

❝ We were into the whole 2000AD comics and influenced by Ian Gibson. I started doing graffiti in about 1984 with my bother (FLX) and Inkie who I grew up with. We started going to all these house parties and warehouse jams because we couldn't get into any nightclubs. We were into it just for the fun, going out at night painting and 'bombing' the city, never really looking too far ahead. We were still kids and whatever we could have been doing would have been naughty in some way, whether it was drinking or smoking. We were never bad kids though.

We were just 'kid' artists, you know there's always a kid in school who's good at art, and we were just that kid. When graffiti hit Bristol for me it was just massive. What really influenced me was seeing 3D pieces going up around Clifton and **Subway Art** hitting at the same time. I mean, seeing it on an international level then seeing it on a local level was unreal. But getting that graffiti 'bible' in your hands was everything; I think this book had the same effect on anyone who saw

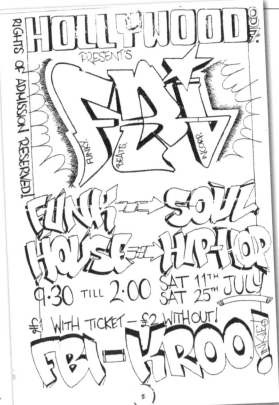

"The beauty about the scene was that it was one scene"

it at the time. And still to this day it's an absolute classic. I don't think there's a graffiti artist outside of New York who hasn't been influenced by **Subway Art**.

Every area had its own kind of sound or crew, we hooked up with FBI Crew because they were from our area

Redland; we knew them from school and hanging out in the same places. Then suddenly guys who you knew from your area were doing big things on the scene and we were part of it, us doing the artwork and those guys doing the sounds. It was all part of the hip hop culture.

I remember not getting in the Dug Out club and when the Moon Club opened I couldn't get in there at first, but after about a year I finally blagged my way in. And once the bouncers start seeing your face regularly, they just leave you alone, even though I was still under age.

But as long as you had the tunes, or the moves, or the skills you were respected regardless of your skin colour or what area you came from. It was all about the music, when we went to parties we got drunk and smoked up but we never were 'off our heads' in the chemical way. The drugs were different back then and nothing too Class A. I think the beauty about the scene was that it was one scene where everyone came together from all over the city to enjoy the 'sound system' vibe and express hip hop culture through their own influences and experiences.

There were very few graffiti artists and only a handful of DJs doing this type of stuff in the city, it's not like now where anyone could be an artist or a DJ.

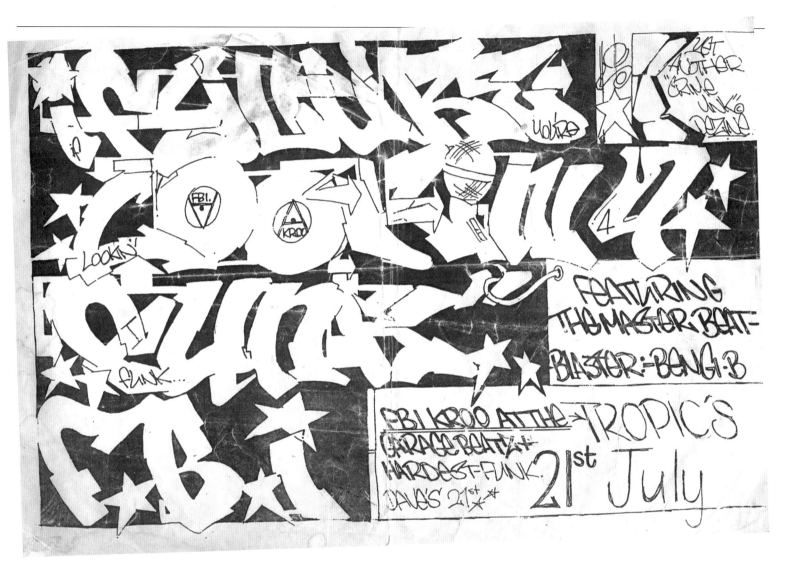

Technics were a hard thing to get and fresh tunes were even harder. Everyone knew each other or knew about each other, and even though there was a lot of intense rivalry there was also a lot of admiration and respect.

When I was doing it, I was competitive. But now that I've faded out of that scene, I can look at graffiti and really love it and appreciate it in a non biased way. I consider myself a very well informed fan as opposed to a graffiti artist now. ✖

Left: FBI at Hollywoods by Crime Inc Crew, 1987

Above: If You're Lookin 4 Funk, FBI at Tropics by Crime Inc Crew

NICK WALKER

1983 - present
Crime Inc Crew, Ninjas of Tag, Original Gods of Graffiti

What music most influenced you?
Mainly hip hop coming from New York at the time – Africa Islam's Zulu Beat show tapes, Kiss & WBLS were the currency of the day.

How and why did you get into graffiti and the hip hop thing?
Hearing Sucker MCs late one night while listening to John Peel properly woke me up to hip hop music. In the early 80s music videos from Blondie and Malcolm McLaren, both featured elements of hip hop culture. The Arena special on BBC2 in 1984 was also a massive insight. Why I got into hip hop was purely because of the fact that it consumes you.

Why did the hip hop scene interest you?
It was and still is a culture that allows people on every level to express themselves. The first thing I got into was B-boying – popping and stuff! I was into what I liked independent of who I hung out with or where I frequented at the time. Eventually you find like-minded people and tastes grow stronger or more eclectic.

Was the design of flyers important to you?
It was cool at the time. I used to do quite a few for Daddy Gee for nights at the

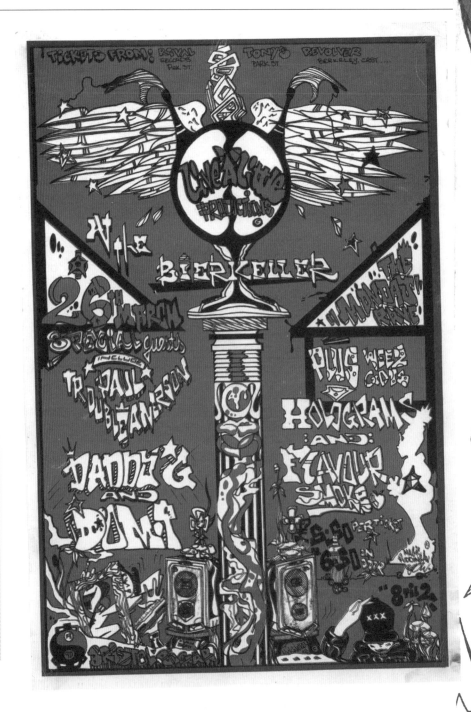

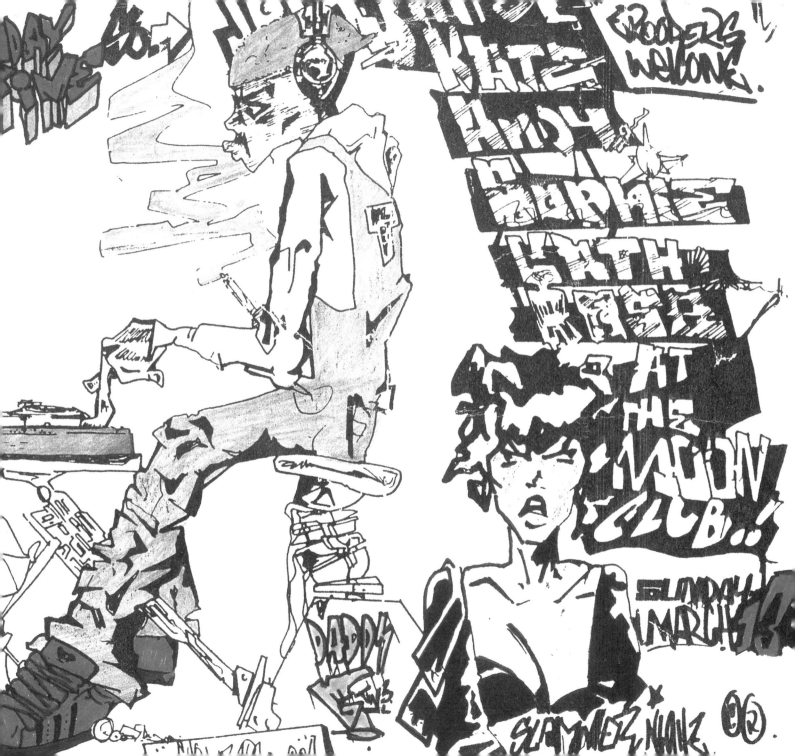

Moon Club etc. Designing flyers was a good way of getting your work about and it was always good to be in the mix. It was at a time when Bristol had a proper scene going on with a number of sound systems all doing house parties or nights at clubs – those days were good.

Do you think flyers were an important part of the scene?
Flyers had a part in creating a scene.

How much do you think Bristol influenced your artistic development?
Growing up in a city which had a good buzz about it was probably conducive. I'm not sure it rained as much in Bristol back then either.

Why do you think Bristol was special in this era?
It was raw – parties, music, hip hop were all better in those days. We all used to hang-out at Special K's which was a melting pot of graffiti artists and DJs. DJ Milo used to come back from New York with the fresh hip hop delicacies of Canal Street. That was the time I got my first pair of grey suede Adidas Campus – the ones with the ball front. Those days were driven by the super enthusiasts. It was all about who had the latest BLS or Kiss tape or if you were in

deep it was the Zulu Beat show tapes you had to get which made the drawing sessions a little bit more out there. A smoke-filled room and the banter of DJs ranting about tunes – nerds the lot us! Hip hop was the new punk and gave people an identity, and I think for some reason a fair share of Bristolians got it bad when the epidemic came to our shores.

What did you think of the Wild Bunch and other crews like Fresh 4, FBI and UD4?
They were all a big part of why Bristol was a good place to be and grow up. Wild Bunch used to smash it the most – proper showmen! There was one year at Carnival when they'd just got back from touring Japan and they dropped a nuts set – lasted all day, I seem to remember one of them mixing the Magic Roundabout theme to some heavy Chicago house tune. FBI were bad ass house DJs and, as far as I remember, used to do the most house parties back then. All it was back then was an empty house, some crufty sofas here and there and the beers stacked next to the decks. It was wall-to-wall party heads and shufflers and I don't recall any serious incidents going down.

What role did Cotham School play in your development?
It didn't.

Did you have any scrapes with the law while doing graffiti?
A few.

What made you and other artists put a piece up on the gym at Cotham School?
You sound like a copper – no comment!

Did you battle any other artists?
Naaaah!

Do you think the mix of races and social class in Bristol in the 80s played a part in the hip hop scene?

Yeah no doubt it affected or contributed to it. Bristol has a large Jamaican population. There have always been reggae sound systems in Bristol which have inspired the likes of Smith & Mighty and Wild Bunch who have themselves inspired people making music today.

Did you know something special was happening in Bristol?

Instinctively I guess so – but at the time I was just absorbing everything about the culture. I think you only realise something special was happening much later.

Did London and New York play a part in your development?

As a sponge you absorb a great deal and many different environments and cities can offer great things – so yes.

How did you get into doing what you're doing now, was it a natural progression?

Yeah just natural progression.

When did you start taking art seriously or did you always take it seriously?

I always took it seriously – never sleep behind the wheel!

Did you think being an artist was a career back then?

I only hoped.

Did any of the New York artists such as Dondi, Seen, Kaze inspire you?

Dondi was the first to inspire me.

What do you think of the graffiti scene in Bristol and the UK as it is now?

It's wigged out – so many more heads have joined in the confusion. It's a lot less generic these days with many new styles being thrown about.

Does the fact that you and other artists like Inkie, 3D and Felix were doing flyers back then make Bristol a focal point for this type of art now?

In Bristol maybe, yeah.

Do you consider the art you produce now as graffiti?

No just art.

Do you still do graffiti?

No.

Will you ever go back to doing 'pieces' like in the old sense?

I've moved on from the traditional styles of graffiti but I still mix it in with what I'm doing now – I like the way the sharpness of the stencils sits with the hand styles.

Are there any funny stories you can remember from back then related to graffiti or flyers?

We all used to hook up round Felix's yard back then and sit designing wild styles and getting mashed up from copious amounts of bongs. Inkie always had this sniffle on the go and if the tape ended he was the one person you could hear.

What is your proudest moment artistically?

Moona Lisa took me to where I am today.

What is your best flyer or the one you like the most?

I'd have to dig them out - it's been a long time since I looked through any of that stuff.

What is your favourite 'piece'?

Too many to list.

What were your favourite parties?

That one in that old abandoned house somewhere in Redland. Or was it Clifton?

What are your most memorable nights?

The ones in Bristol maternity hospital.

Do you get encouragement from other artists from any genre?

Not from them personally, but I like to check out the way the Dutch masters got their metal effects with the colours they used back in the day.

Does the hip hop scene still appeal?

I guess a bit less these days – my tastes have grown more eclectic in general. Hip hop music is very different these days from the golden era of the mid Eighties. I particularly remember 1986 being a good year. I still love listening to a whole bunch of breaks on old mixed tapes – that will never change. ✖

Previous page left: Paul Trouble Anderson, Daddy G and Dom T at the Bierkeller by Nick Walker, 1990

Previous page right:
It's Birthday Time at the Moon Club by Nick Walker

Left: The Sound Of Bristol by Nick Walker, 1989

DEF CON

1984 - 1993

JOHN STAPLETON
IAN DARK

John Stapleton and Ian Dark were into the scene before they became Def Con by collecting records and putting up graffiti respectively. By the late Eighties Def Con were so popular they were able to introduce new music to the jams. They were innovators and continue to re-invent themselves...

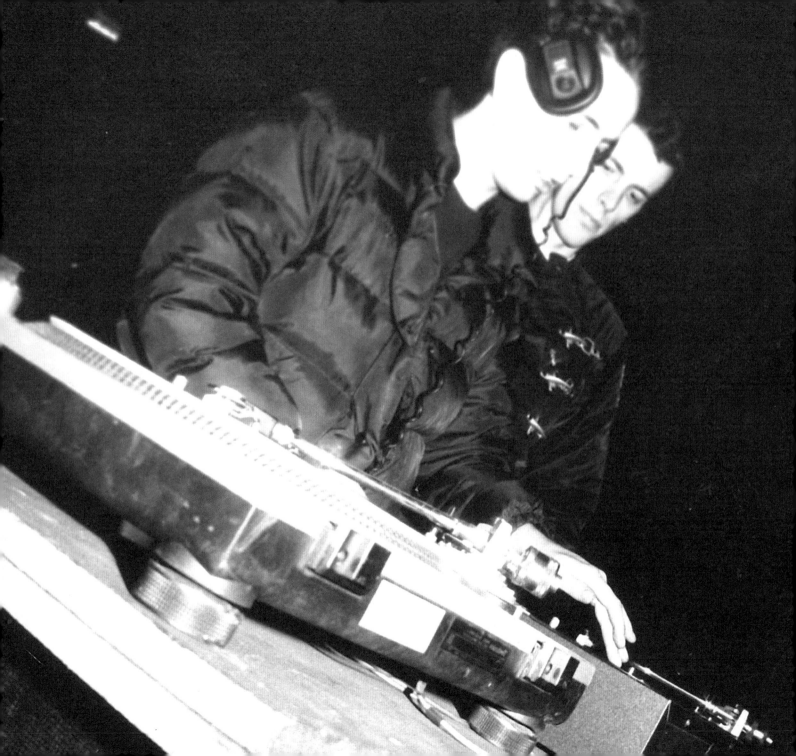

JOHN STAPLETON

" I moved to Bristol at the end of the 1970s and already used to buy loads of tunes. I would turn up at parties with a carrier bag full of tunes and just hog the stereo, I kept at it like that for a while really until I started DJing at friends' parties. Then in 1983 someone asked me to DJ at a benefit night at the Western Star Domino Club, the bloke who owned the club then asked me if I wanted to come down and do every Friday, this was my first proper night. I then met up with a guy called Sebastian Boyle who was a student at Bristol University who wanted to start a club night and needed some DJs, so it was me, Ian Dark, Sebastian and another guy who were doing this night called Club Foot at the Tropic Club, we played Electro and 70s funk – this was around 1984.

What got me into hip hop originally was hearing John Peel playing **Grand Master Flash – Adventures on the Wheels of Steel** and I thought, 'What the fuck is that!' and went out and bought a copy, which took a while and it cost £5 on Import which I thought was a lot, but I just played it to death. But another thing that got me into it was seeing Wild Bunch playing and hearing them cutting up Kurtis Blow and that kind of thing. I think

the second hip hop 12-inch I bought was **Tough** by Kurtis Blow.

I'm a kind of an obsessive record collector and have always collected tunes. I started off buying 60s stuff because a lot of it was around in junk shops and charity shops in the 70s, so it was all Jimi Hendrix and that kind of stuff. Then from there I started to collect soul and funk, but it was kind of odd when I first started to hear hip hip tunes and think: 'Hang on a

minute, I know that sample on that tune, I've got the original'. It's kind of funny because I'm still doing it; I mean I'm still collecting tunes every day.

I think Bristol was special back then, because it was quite different to go out and listen to that type of music. Later when the acid house scene kicked in it was kind of like, that's what everyone did, but back then it was special. When we first started doing Def Con in 1984 or 85, I think we were one of the first who actually rented the whole club out for the night, like when we did The Rummer. But before that I used to play with Manfred in the Moon Club a lot, and back then they used to put a lot of dreadful Indie bands on and the DJs were kind of in between bands, and people used to just come down for the DJs. I remember one night I was playing there and the band didn't turn up, I ended up doing the whole night and it was packed and everyone had a good time and they still only gave me £25. I think the extra £5 was because I didn't have a break. They must have made a lot of money that night with the door and bar money, plus they didn't have to pay £200 to the band. I thought they were taking the piss a bit. So we went and hired out The Rummer and then it just got ridiculous, because at the time if you

wanted to hear hip hop, funk and that type of thing in the centre of town, we were the only place to go.

We did The Rummer for a year, then in around 1986 we had a Xmas special coming up I think the Friday before Xmas. On the day of the party, the venue rang up and said they were flooded. Steve who was our doorman at the time called a few clubs and got to the Thekla and asked what they had on that night, he said we've just lost our club and we've got 300 people coming down with nowhere to go! They guy at the Thekla said they'd got some theatre company down there and they were being really pissy so if you want to come down, the night's yours. So we moved our night to the Thekla at about four hours notice and it became our regular thing. They used to do theatre and weird kinds of performance stuff in there and we were the first to do a club night in that venue. It overlapped a few times – they had this weird performance thing with a guy riding around the stage on a unicycle talking about the history of England in front of about four people. That would finish at about 9.30, then by 10.30 the place would be packed full of people listening to hip hop.

It was always quite mellow though; there would be the kind of bad-boy element, the Clifton College kids and the

"Hang on a minute, I know that sample on that tune, I've got the original"

Redland Girls School girls all mixing together and having a good time. By 1988 we had the Thekla as our resident club and were playing new tunes by Sugar Bear, Kings of Pressure and Tuff Crew. I

worked at Sidetrax Records for about five years and I remember being on the phone ordering new imports knowing that on Friday morning when they came in there would be at least 20 regular people there waiting. Towards the end of Def Con we kind of shifted music policy, around the time of acid house. We would start with acid house and then move to funk and hip hop, when a lot of other people would end with acid house.

Looking back now it was very special, but at the time we just did it because we loved it and it was just 'what we did'. I remember when we did Get Off at St Nicholas House and people came down from other cities and were saying they couldn't believe it, because of the tunes and the vibe, but we'd been doing it for years in Bristol. You would go to different parties all over the city and see the same people there, say if you went to an FBI party you would see Prime Time there and if you went to a UD4 party, City Rockas would be there. It was all mixed, everyone went to each other's parties.

I used to really enjoy the Def Con Cooker nights where we had a lot of live bands on like Roy Ayres (the first time), Incognito and Lonnie Liston Smith.

I remember Wild Bunch and Newtrament at the Redhouse as being just ludicrous!

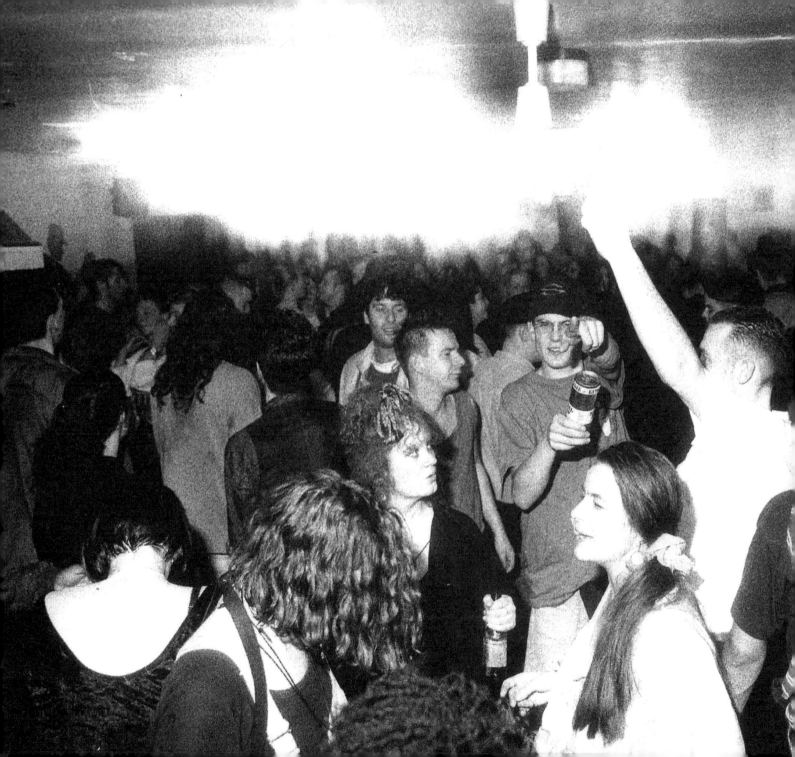

I used to go to a lot of different kinds of stuff at that place but that Wild Bunch night killed that venue because it was just so packed! But it was a death trap of a venue, no toilets, bricks and stuff all over the floor just as rough as you like. I also used to really like stuff at the Sculpture Shed. This was an artists' studio on the docks down by the ss Great Britain, I think Gary Clail and Mark Stewart played there a few times. There was a mixture of different bands, dub reggae and DJs there; this was another of these mad Bristol spaces at around the same time as the Redhouse. I also remember doing a party in Redcliffe caves once, this was a totally mad illegal party; we got a generator down there and set the decks up. I can't remember why the caves weren't locked; I think there was another secret way you could get in there at the time.

I think flyers were important then because it was before computers so most of the stuff was hand-made and we used to take pride in that. People would come just to get the new flyers because they knew they could get into the next jam if they had the flyer. It got to the stage when we started doing membership cards. Some people even started selling them for like £10! Then someone turned up with our membership card printed on a T-shirt. It was out of control! It was different to nowadays because you can do it all on a

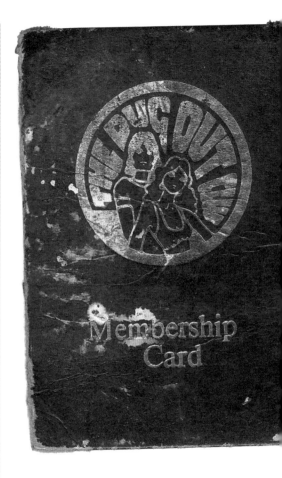

Previous page 43: Def Con;
John Stapleton and Ian Dark
at the Thekla, 1988

Previous page 44: Def Con
at the Thekla by Oli Timmins

Previous page 45:
Destination Moon –
Def Con at the Thekla, 1988,
by Oli Timmins

Left:
Get Off at St Nicholas
House, 1992

Above:
John Stapleton's Dug Out
membership card, circa 1981

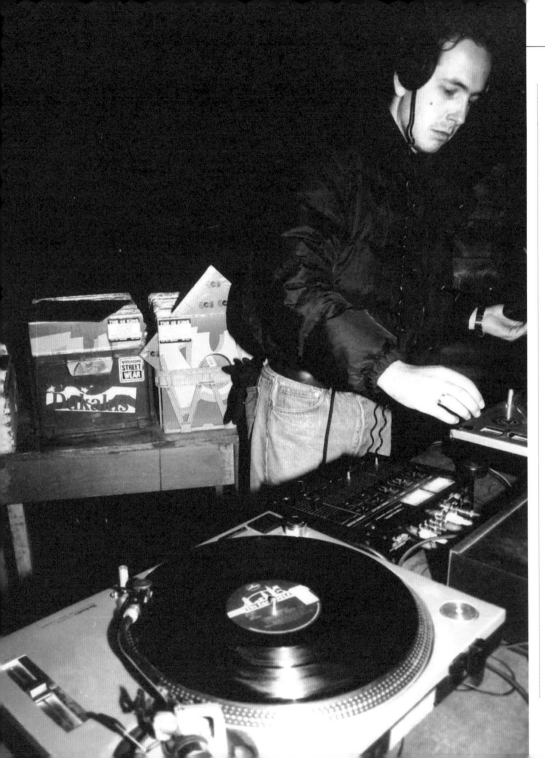

computer get it printed up and get Out Of Hand to package it all up and distribute it. It was a lot more involving then and nobody really knew how to do it, and that's always when the most interesting things happen.

I remember saving up and going to New York in 1988 and being blown away by all the stuff going on there. I remember seeing Afrika Bambaata playing at Mars Club – seeing the type of stuff that we'd only seen on **Style Wars** or **Wild Style** was just mind blowing.

I've always promoted my own nights and played at them and I still do the same now, it isn't really a natural progression, it's what I've always done. I think Bristol played a big part in my development in so much as I wouldn't be doing what I'm doing now if it wasn't for Bristol. I don't necessarily think there was one 'golden era' in Bristol, some people say their 'golden era' ended when the Dug Out closed in 1986, but I think Bristol always re-invents itself and will continue to do so. ✖

IAN DARK

" I was getting into music before I was in Z Boys. I was well into The Clash and they really had an effect on me. That group is what first introduced me to reggae. I was a little white boy living in Cotham listening to The Clash, this was about 1977, and I found out some of their tunes were based on reggae music. By 1979 I was also into punk; this too had an energy that I got hooked on. Around this time I'd heard very early hip hop but it wasn't till 1982 when I saw the film Wild Style that I just had to start painting. What also attracted me to graff was the 'look at me, but you don't know who I am' factor. I was buying tunes and buying and nicking cans of spray paint, but doing graff was my first form of expression in the hip hop scene. I didn't know how to do it, no one really did at the time, I was learning as I was doing it.

I started to think about being a DJ after going to Wild Bunch parties and 2Bad nights. At first I wasn't too into mixing, I was into 'cutting up' breaks after seeing Flash in his kitchen in the film **Wild Style**. I had the tune already and couldn't believe that he could actually do those cuts live, it just blew my mind. I first started going to the Dug Out club on Wednesday nights when Grant [Daddy G] used to play there.

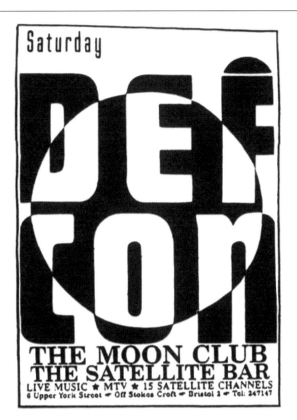

I think Wednesday nights was just Grant playing originally and then it became the Wild Bunch night. I think the Dug Out was where all the elements of this scene met up and then created everything else.

I lived up the hill from St Paul's, in Cotham and at the time there were only two black kids in my school, so when I used to go to the Dug Out it had such a mix of people there that it just seemed like a bit of an oasis. I liked that because there wasn't a mix of people like that without any serious violence anywhere in

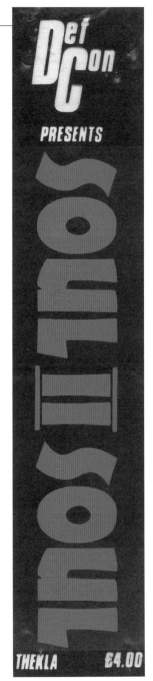

Left: Ian Dark at the Thekla, 1988

Above left: Def Con at the Moon Club by Oli Timmins

Right: Def Con presents Soul II Soul at the Thekla by Oli Timmins, 1989

the city at the time. I knew a lot of black people got grief in city centre clubs but not in the Dug Out as far as I remember, and to a degree vice versa; white boys could go down to the 'blues' clubs in St Paul's and not get too much hassle. Looking back to those days it seems that this sort of thing was happening up and down the country, but I don't think it was, Bristol was unique and very special. It seemed like it was only a year when it went from just having the Dug Out nights to warehouse parties and St. Paul's Festival. It wasn't organised or planned, it was kind of hit 'n' miss and maybe that's the beauty of it.

The Moon Club came soon after the Dug Out closed and by this time there were more people into the scene. In the Dug Out days there was only a small group of people into it but by the time of the Moon Club it had really taken hold. The first nights I went to at the Moon Club were 2Bad Crew on a Thursday I think. After that the best nights for me were when I played there myself, you know. I remember people with their hands in the air all the way from the stage to the back of the club, which was amazing. Another incredible thing about it was that the club closed at 1am or 2am and when the lights came on the club was still rammed, everyone stayed there till the last

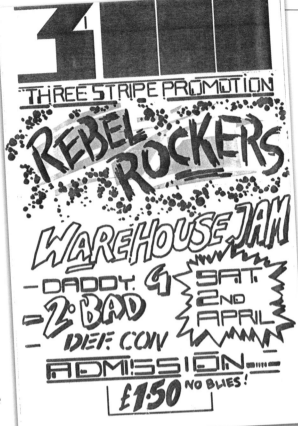

"I know I shouldn't be here... but I'm here anyway"

tune, and it was like that every week. The house parties in Bristol were special too, they weren't like your traditional house party, they had this 'shebeen', 'blues' club feel to them, you pay your £1 or 'blag' your way in, go through into these dark rooms with one light on above the decks

with darkness and party people everywhere else. I think this was different to other cities even though I know London had this type of scene going on as well. Bristol is a small city and this scene was even smaller, so you'd bump into the same people all the time. Maybe that's why Bristol is so laid back because if you were putting on a party all you had to do was print up a few flyers, tell a few people about it and everyone would be there. In London you probably had to be more aggressive about it. But I equate it to chatting up birds – in Bristol if you see a nice girl, you don't have to get her number right away because you know you're gonna see her again next week or something, but in London you've got to get that number there and then because if she walks out that door you ain't seeing her ever again!

But the club that people associate us with the most was the Thekla. I think the first night we ever played down there they let us have it for free before they started to get wise with the amount of people coming down and filling it out, I think they charged us £30 to hire it out! I remember they changed the stairs around a lot and it was only half the boat downstairs and there was no upstairs originally until they re-fitted it. We put on Soul II Soul down there before they were really big and I

remember it was 11pm, there was a big queue outside and they hadn't turned up. When they did show up all they had was a tape and not even the full crew, I was quite disappointed with that but Jazzy B later apologised about it.

The one thing that differentiated Def Con from everybody else was that we were prepared to play the so-called popular tunes that people wanted to hear even though we introduced a lot of new stuff at the time. We just knew for a fact that everyone would jump up at Young MC, Rob Base, Sugar Bear and whole bunch of funk and rare groove stuff like Jocelyn Brown and Maceio and the Macs, so we played them. At the time there were a lot of people standing around who were DJs or wanted to be DJs saying 'oh not that tune again', but I would say 'look around, that's why I get paid every Saturday night and you don't!'

Another thing I remember from the Thekla was the big guy on the door, Pohl I think his name was. He was like a pirate in combat outfit and a bandana, could've easily had an eye patch and a parrot on his shoulder. He was a nice guy generally but you wouldn't want to fuck with him! I even remember people climbing in through the portholes and jumping from the roof onto the dance floor or rushing in through the fire escape door at the top of the stairs behind the stage.

I think all these parties brought the 'blues club' element to them. The Dug Out was like one of those old 'shebeens' with all the dark little rooms and that, I think the Moon Club and the Thekla were an extension of that, it brought that same illegal 'I know I shouldn't be here' vibe to it. That's why I don't like these big 'raves' and super clubs with VIP areas, because it's always been about the underground illegal rebellious thing like the Dug Out; I was too young so I shouldn't have been there, the warehouse parties were illegal so I shouldn't have been there and the 'blues' clubs... for a whole host of reasons I shouldn't have been there! By the time the organised 'raves' kicked in it was legal and I wasn't into it anymore.

I did design a few early flyers but I quickly realised I was better at DJing than doing flyers so we got Oli Timmins and Matt Mills to do them. We even had little sweets and plastic stickers in a bag with the flyers you know, all sorts of gimmicks. We were just trying to look a bit different.

I was in Def Con first then later 98 Proof with Nick Warren and Daddy G. The last time I played a Def Con night at the

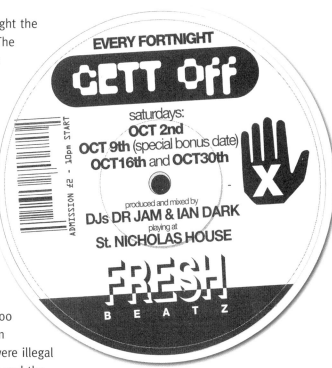

Thekla was the same day I signed my first record deal with Jive Records. I came back from London with a nice fat check and I think I came and played the last tune of the night, it was a good way to sign out. Me and John were doing a night called Get Off by this time at St Nicholas House in St Paul's, this too had the illegal 'blues' feel to it and seemed to go on for ages into the mid-Nineties. It ended up being Venue magazine's Club Night of the Year after six months. ✖

DJ LYNX
SOUL FORCE/3PM
1986 - 1993
DJ 1986 - PRESENT

Practice and perfection was his mantra... Lynx has a
love affair with hip hop music and has been involved
in some memorable nights. Along with 3PM he also
featured on some classic tunes with Smith & Mighty

DJ LYNX

" **My first DJ spot was at Mozart's Club (where The Croft is now) on Stokes Croft in around 1986 when I was 17 years old. It was a soul night but I used play a few hip hop tunes. This was with a crew called Soul Force, which was me, Spider C and DJ T. I had always had my own identity though and being in Soul Force crew was mainly about playing in Mozart's at the time.**

I first got the hip hop bug seeing Jeffrey Daniels (Shalamar) doing his thing on **Top of The Pops** (before Michael Jackson) back in 1982. That got me into the breakdancing side of it. Then I saw the **Buffalo Gals** video and it was over, I was hooked!

I was into Street Sounds Electros and was getting hold of Kiss FM and WBLS tapes fresh from NY at the time. I used to listen to these tapes intensely, the way Red Alert was cutting up the tunes and mixing was awesome. The first tunes I bought were Afrika Bambaata, David Joseph, **Buffalo Girls**, some of the early Street Sounds Electros and the **Wild Style** soundtrack.

4 those who know

HOMEES

KINGS night club

14 Park Row Bristol

DJ LYNX & JNR.

Thur' 3 March 94 | 10-2 | £3.00 on da door

I remember going to London with a friend and him buying an amp, a Sony deck and a Technics deck, not a 1200 but the one with a strobe light on it. We put the set up on the frame of an old snooker table with a door across it – proper ragga! I used to try to go round his house every day to practise on his decks, but I couldn't go there all the time for whatever reason so I thought I needed my own set up. I bought one 1200 with a credit card and the other with money I'd saved up. This is when the DJ thing really started for me because I just stayed in all the time and practised. My thing was, and always is, practice and perfection.

I hooked up with Soul Twins in 1987 or 1988 and they asked if I wanted a spot on Bad Radio, which I jumped at even though I didn't have a vast collection. Spider C had Technics early and could mix really well, I could scratch before I could mix so I had to learn how to mix as well.

But the main influence on me at the time was The General (UD4), he was on some other shit. His scratching and mixing was futuristic, just way above everyone else at the time. He was my mentor even though I didn't know him personally, I would go

to UD4 parties and get his tapes and just listen to him. When I eventually met him and went round his house I saw he had the mixer in the middle of the decks! At that time most people had two decks together and the mixer on the end. He said to me that it was easier and quicker to have the mixer in the middle. When I got home I did as he said and haven't looked back since.

I never really got into battling other DJs or competitions at the time because I didn't feel under pressure, I had the confidence and I was at my apex. I knew I had nothing to worry about. But the only competition I went in for was for a residency at Studios (above where Carling Academy is now), Tristan B was the host. I remember Geoff [now of Portishead] and Joel Jackson from City Rockas Jnr were in the competition as well. I had my special mix well prepared – **Rock the Bells** (LL Cool J) over the theme tune from **Grange Hill**, I mean it was wicked and I pulled it off perfect at the time but in the end Joel Jackson won it and got the residency. I was so burned after that it really put me off and I never went in for a competition again. Even Joel came up to me at the end and said I should have won.

My favourite party in a club must be Afrika Bambaata at Studios in 1986, I mean Afrika Bambaata in Bristol... Come

"I had my special mix well prepared – Rock the Bells (LL Cool J) over the theme tune from Grange Hill..."

on! I also miss real Bristol house parties because there was nothing like these anywhere else, they were just so special

it's hard to put into words; you had to be there.

I got into making music because I was on Bad Radio at the time and Kelz and Krissy Kriss were doing stuff with Smith & Mighty. They needed a DJ for a tune they were making and asked me to go over to Smith & Mighty's with them one night. When I got there I couldn't believe the equipment, I mean drum machines, samplers, keyboards and stuff, I was quite overwhelmed. They said to have a mix on this deck which was on the floor, they were just so laid back. Before I knew it I was going round there all the time and put some of my cuts onto some tunes. I even remember when they made their acid tune in 1988. We were round there and when we heard it we said this tune is 'acid off a way' and that's what they called it. Through these jamming sessions me, Krissy and Kelz came up with a name for ourselves, 3PM. This stood for 3 man Posse Move. I think we got the name at 3 in the morning as well, so that was special. ✖

Previous page 53: Lightin Up, DJ Lynx mix tape by Barney, 1993

Left: Homees at Kings Nightclub by Barney, 1994

Above: Halloween Ball by Nick Walker, 1991

EMERGENCY RADIO

99.9FM · 1988

Pirate radio had an immense effect on the scene
by giving a new platform for the subculture and
taking artists to new audiences. Some of the
biggest names on the scene did sets as
Emergency Radio became essential listening

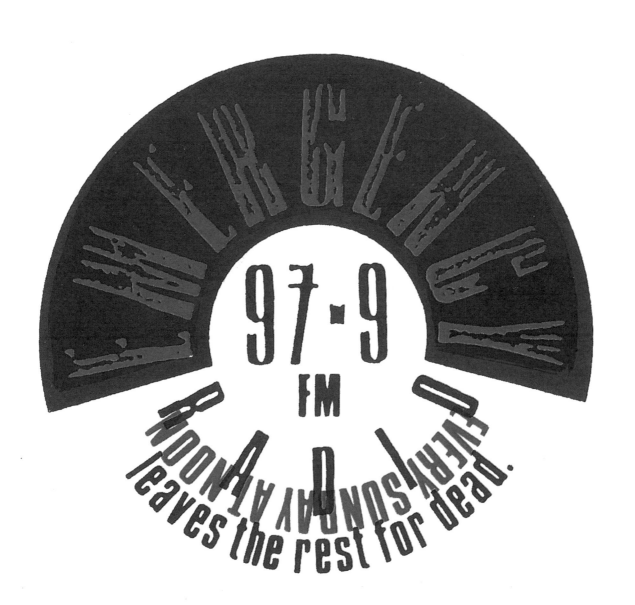

EMERGENCY

97·9
FM

RADIO

EVERYSUNDAY AT NOON

leaves the rest for dead.

PAUL HASSAN

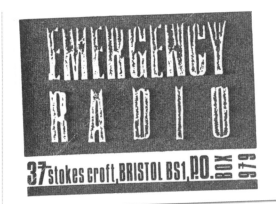

" A group of about five or six of us got hold of an old transmitter in late 1987 or early 1988, we found a frequency which we thought was empty – 99.9FM. I remember us having a brainstorm and coming with the name Emergency Radio. We talked to Daddy G (Massive Attack) and John Stapleton (Def Con) and Baby Malc about playing tunes and getting together to organise the whole thing. I mean we wanted to take this thing really seriously and didn't even want to be called Pirate Radio we preferred Unlicensed Radio.

We got loads of oversized posters printed up and then got 'Crazy Veronica' to go and put them up around the city. We had Carlton who had just cut a record with Daddy G to sing a jingle for us, we had Ragga jingles too. We even went to London and got that guy with the baritone voice who does all the film trailers to do few jingles as well! We had proper adverts from clubs, record shops and magazines. The advertisers couldn't get prosecuted at that time so it was cool. The transmitter was moved around a lot, from St Paul's and Montpelier to Bishopston and Clifton.

We had some real diverse sounds on

"It was good to have that amount of pirates on the the air like, Bad Radio, Raw FM and FTP – unlike today"

the station like Daddy G and DJ Milo playing the rawest hip hop and breaks; AJ and Carlo (Latin and African beats); Manfred (P funk and go-go); Dom T from 2Bad (house, hip hop and funk), Dizzy T from City Rockas (rare groove); Baby Malc (slow jams); Lewi from City Rockas (Philly sounds); Hidden Strength (roots and culture); Queen Bee (strictly Studio One cuts). We had guest sessions with the likes of Fresh 4 and Justin Berkman who was one of the original Ministry Of Sound DJs, he played house, dance and US garage. Jazzy B (Soul II Soul) did a special

show for us too.

After a few months we realised that the frequency we were on '99.9 FM' was actually a special frequency being used by the government or Special Branch or something! So we quickly moved to 97.9 FM. After this we got hold of a microphone link transmitter which was state of the art at the time and we never got busted, while other stations got turned over regularly. It was a really cool time and we got on well with all the other pirate stations. It was good to have that amount of pirates on the air like, Bad Radio, Raw FM and FTP, unlike today.

Emergency lasted about a year; we even tried to get a licence. We partnered up with Venue magazine and put in a bid. I think we were going to call it Crystal Radio. But FTP won, they got the licence and that was that. ✖

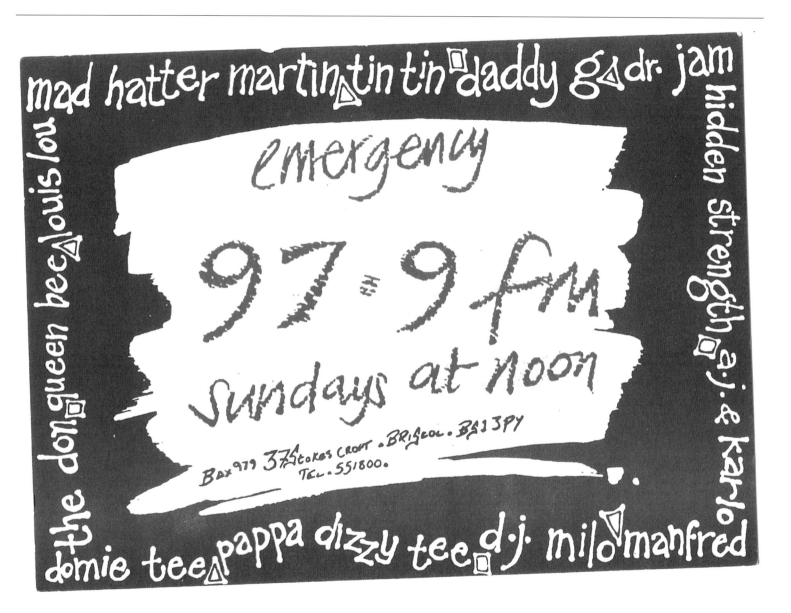

mad hatter martin tin tin daddy g dr. jam

hidden strength a.j. & karlo

emergency
97·9 fm
sundays at noon

Box 979 37A Stokes Croft · Bristol · BS1 3PY
Tel. 551800.

the don queen bee louis lou

domie tee pappa dizzy tee d.j. milo manfred

Left: Emergency Radio
headed paper, 1988

Page 57: Emergency Radio
sticker, 1988

Above: Emergency Radio
flyer, 1988

FBI CREW

1984 - 1989

PAUL CLEAVES
PHIL JONES
MARK CLEAVES
PAUL SMART
DAVE McCARTHY

Even though FBI became fixtures at the Moon Club, Hollywood's and Tropic, they will always be most strongly associated with house parties. They were avid collectors of tunes and perfectionists when it came to mixing...

PAUL CLEAVES
MARK CLEAVES
PAUL SMART

" **Paul Cleaves: My main influence regarding the music was around mid 1983. A good friend of mine called Julius Wells used to visit an associate above the Rainbow Cafe in Clifton. Coincidently, the Wild Bunch used to have their set-up in the same building. Julius was given two NY radio station tapes, a Shep Pettibone KISS FM and a WBLS funk tape. After hearing these sessions I wanted to be a DJ, I hooked up with Sean Bradley and Phil Jones, got some plastic decks, a mixer with no x-fade from Tandy and (shall we say) the rest is history.**

Mark Cleaves: I remember when the Wild Bunch got about 40 people together and coached us to a venue in London called the Titanic Club. It was on two levels and looked pretty much like a ship inside. These were pre-Dug Out days and my first experience of a jam down. Wild Bunch battled DJs like Newtrament (of **London Bridge Is Falling Down** fame), I was about 17 at the time and remember feeling well cool having been asked to carry a box of their prized records from the coach into

the club. This was the era when Wild Bunch had the L.A.D (London Acoustic Developments) decks and Newtrament had Technics 1200s. Technics 1200s were hard to get in those days. I seem to remember they were being discontinued, so you had to specially order them from the Technics shop on Park Street and had to wait months.

PC: Bristol in those days had commercial venues like, Busbys, Vadims, Romeo and Juliets, Mistys, Crystals and Tiffanys. DJ crews used underground venues like the Docklands Settlement, the Redhouse, The

Western Star Domino Club, Dingys, Backline and any other warehouse, abandoned building and house that was made available. Early 1984 spawned the underground clubs, Tropics, Thekla, and the Moon Club. The most memorable warehouse party I've been to was Wild Bunch at the Redhouse, that was totally underground and fresh, you knew this was well and truly the party-rap/electro age. At that time all we were interested in was what records were being played. We were generally found in a huddle in front of the decks trying to glimpse a record label or the faintest half word of a name.

Wild Bunch were the originators but there were some other crews doing their thing as well like City Rockas and Galaxy Affair who were playing funk and soul from way back and never really get a shout so we would like to mention them now out of respect.

MC: There were other crews too like 2Bad, and UD4 who were wicked DJs as well and had some serious tunes. We also knew Dominic Thrupp and Ed Sargent (2Bad) from way back, so all these guys influenced us in some way or another.

"Wild Bunch were the originators but there were some other crews doing their thing as well..."

PC: We did encounter some setbacks along the way –Sean's departure, John Palmer's arrival who also left to be replaced by Dave McCarthy and Paul Smart. New equipment was bought which included the much sought-after GLI PMX 9000 mixer – at last the set-up was complete, Funky Beats Inc was coined and by early 1985 FBI was firmly established.

It wasn't all a bed of roses though, a lot of crews and people got treated rough. I

funky
beats
inc

TUA
'the
ultimate
artists'
Fade
inky
jaffa

inky 85

The FBI Presents Funk Delux.
Rockin the Dugout on the 21st March

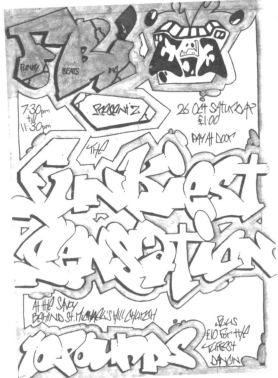

were banned from parties, I remember a Wild Bunch party on City Road and they wouldn't let him in. I also remember we did a party for Felix's 18th Birthday on Clyde Road, Redland when we got FBI/Crime Inc T-shirts done. I knew Felix from school where we were in the same class. I always knew his graffiti thing and it just fitted with what we were doing at the time.

MC: I first met Inkie at Spellbound amusement arcade in Clifton in 1984 or 1985, we used to hang out there a bit. We used to call him Tom Teeth! Sorry Tom! He was in a crew called The Ultimate Artists with Fade and Jaffa, he came back to Sean's house one evening where the set-up was and just freaked out over the Technics because no one really had them then. So those guys were with us from the early days and them doing graff for us was just natural.

PC: The place to get British soul and funk was Soundsville Records on Gloucester Road. We used to go there all the time and get 12-inch promos of stuff like Loose Ends, Sahara and Total Contrast.

mean, we got put down a lot, I remember going into certain parties in the early days and hearing, 'Oh here they are then… The KGB'! In reference to the name FBI, I suppose it was quite funny really when you look back because it was banter, it also made us more determined. I remember the Wild Bunch thought that Sean Bradley had tagged over a 3D and

"We would go to London to get our fresh imports from Groove Records…"

Z-Boys piece in Hampton Lane, Redland, and once your name was put in the frame, you were dirt and it just stuck. You

MC: We would go to London to get our fresh imports from Groove Records or Bluebird (Church Street) but then go to the Record & Tape exchanges and other small record shops to get our classic tunes. They were so cheap we'd come back with a crate of tunes, but it wasn't fun lugging it round London then onto a coach back to Bristol.

PC: By 1987 the scene was changing and other styles of music were getting popular. People like John Stapleton [Def Con] who had some serious tunes, originals on 7-inch and loved to play rare grooves and breaks were filling venues like the Rummer and Thekla. In many ways our 1987 Hollywood's party was the rise and fall of FBI Crew because it was one of our biggest nights and it kind of went downhill after that. We were still into the Chicago and NY house mode but the scene was moving away from us and to be honest we really didn't see it coming. It was also at around that time Phil Jones left the crew to go off and do his own thing.

MC: We still did house parties and that but it wasn't until about 1989 when Criss Cross was doing Triple XXX and Club Yeyo nights that got us back in the game. You have to remember all people really did in those very early days was smoke a draw

Page 61:
FBI House Party, Hampton Park, Redland by Inkie, 1986

Page 62: FBI at the Moon Club by Inkie and FLX (CIC), 1988

Page 63: FBI at the Mayfair Rooms by Crime Inc Crew (CIC), 1989

Far left: FBI – Funk Deluxe at the Dug Out by Inkie, 1985

Left: FBI Crew – The Funkiest Sensation at the Savoy by Inkie, 1985

Right: FBI, 2Tuff and Dirty Den at Sunset Rendezvous

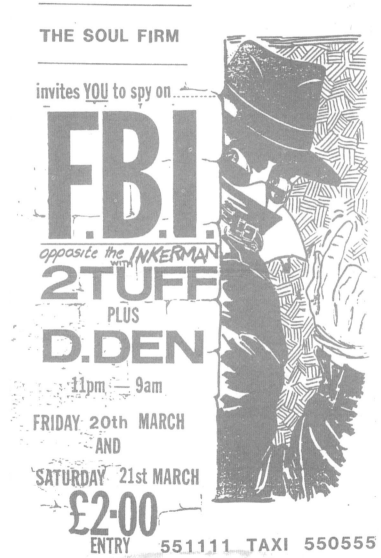

THE SOUL FIRM

invites YOU to spy on...

F.B.I.

opposite the INKERMAN with

2TUFF

PLUS

D.DEN

11pm — 9am

FRIDAY 20th MARCH

AND

SATURDAY 21st MARCH

£2·00

ENTRY 551111 TAXI 550555

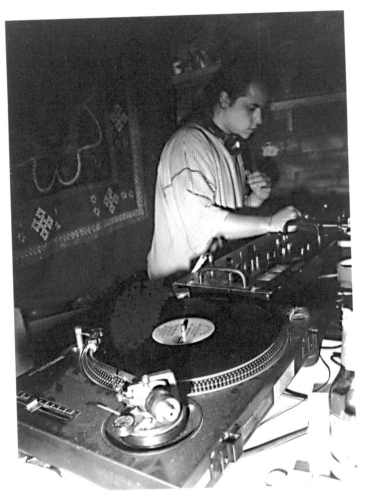

"All people really did in those very early days was smoke a draw and drink Tennants Super"

seemed he'd just had enough and stopped DJing. I remember one day they [Prime Time] were gonna play in an abandoned church in Cotham or Redland and it burnt down, there were rumours of sabotage but who would burn down a church to stop a rival crew from having a party! There were a lot of 'Bristol bullshit' rumours coming down the grapevine in those days.

PC: In about late 1988/1989 Rich Mallett who was an old friend who we'd known for years and who we'd shared a flat with in Clifton and a house on Muller Road, Horfield bought an Akai sampler, I got into making music with him, Felix and Matt Lucas. We went to an opening of a recording studio in an industrial estate in Bedminster and we hired a part of a studio for something like £20 each a week. We ended up releasing a handfull of tunes on Kongcrete Records.

Paul Smart: Our first Party as FBI was at 87 York Road, Montpelier in 1985 or 1986 at Jason Garland's house. I remember because the Wild Bunch turned up and we were under pressure to perform, because being a DJ back then was a lot more than just playing records, you had to know your stuff and show your skills. This was the first time I met the Wild Bunch and after a while I got on the decks and

and drink Tennants Super and that was as strong as it got. It was a lot mellower and the music was a lot slower than it is now. It wasn't until acid house and jungle that the music got really faster and the drugs seemed to get heavier and more aggressive, and that's when it really killed it for us. Phil Jones was a serious DJ back

then too. It was early 1985 (the Tropic Club era) when he was really on top form, I reckon, this was when FBI were peaking as well. I have to say one of the most serious scratchers I ever saw was Justin Britton [DJ Apollo] from Prime Time Crew; he was like some DJ Cheese or CJ Mackintosh. But then suddenly one day it

started to mix up two copies of **Paul Revere** by the Beastie Boys and 3D got on the mic and started to flow over the mix. I think that was a kind of acknowledgement that we were up to scratch and we get on well with them till this day.

Another memorable night was the party at Phil's house on Hampton Park in Redland in 1986. It was rammed wall to wall and he put mattresses in the windows to dampen the sound, but it was useless because you could hear it from a mile away. But for me the most legendary FBI party was the one on St Paul's Road in Clifton. This was the first time I saw a party literally cause a road block. People were hanging out of the windows and the floorboards were warping out of shape. I mean, you couldn't walk around in that house it was just so dangerously packed. The police came in riot gear and blocked off each end of the road with meat wagons – it even made front page in the **Evening Post** the next day. This was in 1988 or 1989 when the police really started to crack down on illegal parties and before the scene moved into more organised raves.

We were a house party and warehouse crew. We never really played in clubs like Hollywood's, The Granary and The Moon Club till around 1987. We started out

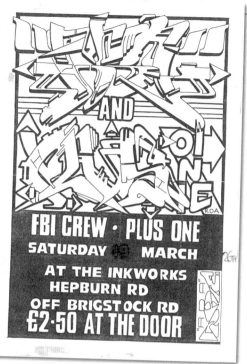

doing birthday parties for friends and so on. I remember other crazy parties we did like Anchor Road warehouse with Prime Time Crew (this is where @ Bristol is now), Upper Perry Hill in Southville, Head Quarters on Ashley Road and at Jackal's house on Arley Hill. Club nights for us started after we got a reputation in the house party scene and people started to trust us to fill a club.

If anyone's parents in the crew went away we would get the decks and system round their house and have a mix up and a smoke up for days. I remember one day after me, Dave McCarthy and Mark Cleaves came back from London buying

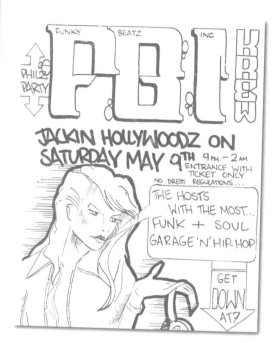

tunes and went round to Phil's house, walking up the drive and seeing our equipment in the front garden, decks with the tone arm broken and stuff! Turns out his mum got fed up with the constant bass lines and decided to throw the decks out the window! Phil said she even tried to throw the tunes out too, but 15 crates were too heavy for her, thank God! ✖

Left: Paul Cleaves on the decks at FBI house party, 1986

Above left : FBI and Plus One at the Inkworks by Inkie (RDA), 1987

Above right: Phil's Party at Hollywoods by Inkie & FLX, 1987

FRESH FOUR

1984 - 1991

Coming out of Knowle West, Fresh 4 brought a new energy and style
to the scene. Their St Luke's Road parties are the stuff of legend,
and they also created one of the definitive sounds of Bristol

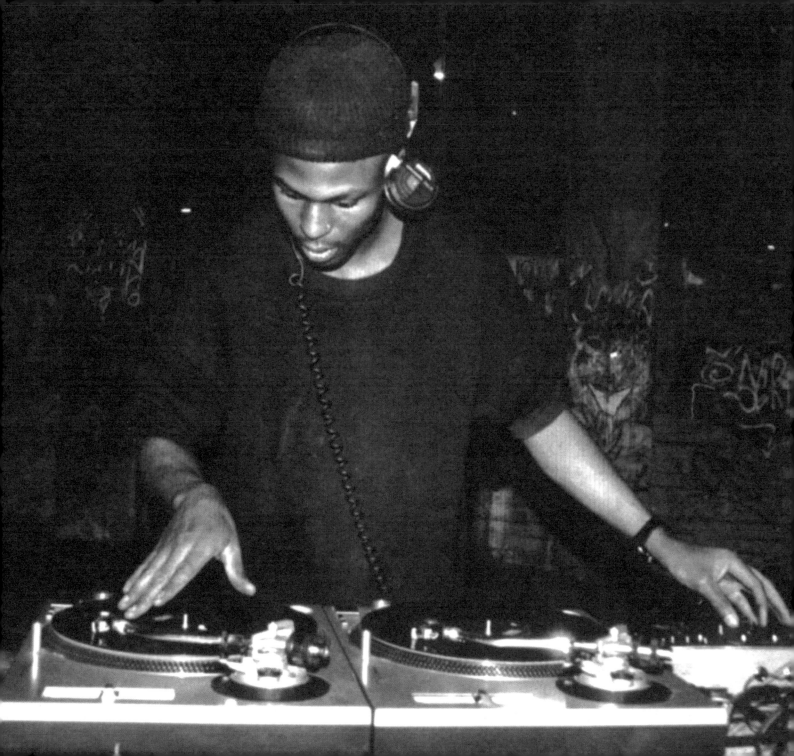

FLYNN

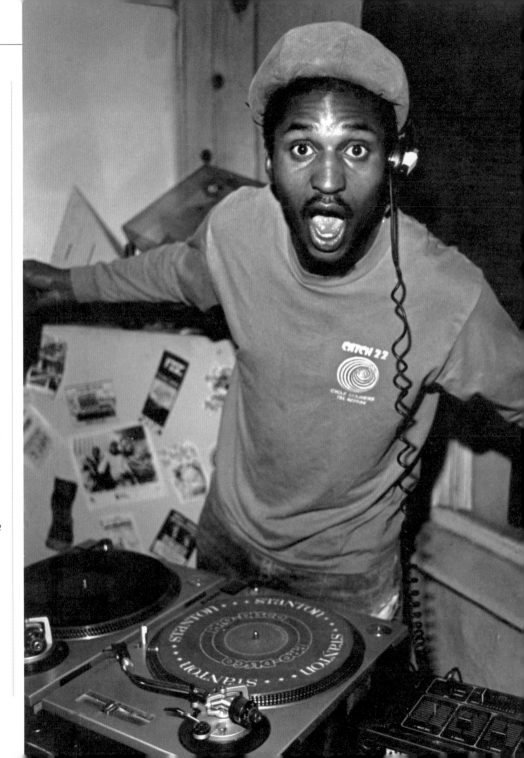

" We got interested in music and records through my older brother – we'd go into his bedroom and mess around with his stuff like records, tape decks and that. Back then hip hop was so new to everyone – not like it is now because it's mainstream. From the minute I first heard it, it just took a hold and never let go. We used to scratch on old belt drive turntables, then we got hold of some Technics, they weren't 1200s but they had pitch control so we could mix better. We were making our own mix tapes as well by cutting, pasting and splicing tapes together. We got 1200s later and started to scratch and mix properly. We knew there were other crews out there and competition was hot, so we all just practised, me and Suv in particular practised scratching relentlessly.

The scene back then was such a mixture of different people who I suppose were looking for something. There were punks, jitters, mods, new romantics – every scene had a kind of label, a clearly defined identity. People were just rebelling against something. We knew about these scenes but didn't fit into any of them, but when hip hop came along it just spoke to us on a different level.

Hip hop back then was a mixture of different art forms from break dancing and graffiti, to being a DJ or an MC. So it was like any one could get into it because there was so much you could be into. The mixture of cultures and areas of the city is what made Bristol so special, people from all walks of life got into it. But it wasn't mainstream, it was underground. We had the word 'sub-culture' on some of our flyers and that was what it was.

The first party we did was at Eagle House in Knowle West and that was about 1984 or 85. Krust put our first flyers together, he just came up with the design and we loved it and it went from there. At about this time we were hanging out at Sid's on St Luke's Road, Totterdown, it was like some 1940s sweet shop. In the squat behind Sid's there were a lot of different kinds of people down there with a likeminded free and liberal attitude, we used to knock off school and hang out there and all of a sudden we were there all the time, chilling, smoking weed, playing music and shit. Before we knew it we were squatting down there. We put our set up there when we got the idea to do a party there for south Bristol – at the time most Wild Bunch or FBI Crew parties were happening in St Paul's, Montpelier, or Clifton and Redland. Bristol back then was more area orientated. People from central Bristol wouldn't travel to south

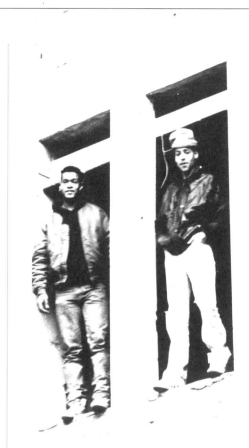

Bristol, or anywhere outside of central Bristol. We knew all the abandoned houses in and around south Bristol but we started to use St Luke's Road as our base.

People started to come to our parties at St Luke's Road from all over Bristol, I remember seeing Inkie and Nick Walker there and loads of different people from all walks of life and all parts of Bristol. We never made any money really because

"When hip hop came along it just spoke to us on a different level..."

it was never about that. As long as we covered the cost of the sound system and the generator and maybe a bit to buy a few new tunes we were happy. I mean we

Page 69: Flynn at St Luke's Road party, 1988

Left: Krust at the Fresh 4 HQ, 1988

Above: Fresh 4 at Westmoreland House, Stokes Croft, 1988. Check out Krusts's latest art and music project at www.rue4.co.uk

WWW.RUE4.CO.UK

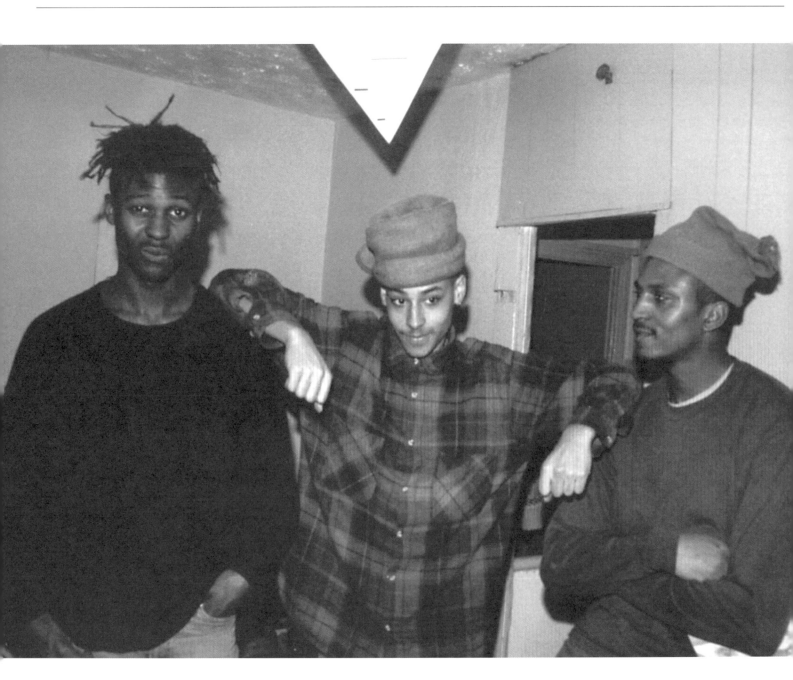

only charged about £1.50 to get in!

This was a real special time for us because people were coming to our manor to listen to us playing our tunes, to us that was a massive turning point, it said to us we can't go any further, we should take it to the next step. I mean we had the DJs, the MCs and we had the venues sorted out, we had done everything we could possibly do so we thought we should start making music. We'd done parties all over Bristol, and played in all the clubs by now and

"We shot the video at the squat in St Luke's Road because that's where we started out"

wanted to bring it all back to south Bristol. We were trying to make a dub plate to play at our St Luke's Road parties. My older brother was buying equipment and showing us how to use it and after a while we knew we needed to get into a studio. Then we saw Smith & Mighty on TV say if anyone had any tunes or wanted to make music, they would listen to them. So we took our tune we were working on (**Wishing On A Star**) to them and they liked it and then their manager heard it, took us to London and the rest as they say is history. It took

Left: Flynn, Suv and Krust

Right: Brothers In Bass and DJs Suv & Krust house party at Cobourg Road, 1991

about a year to do but when it was released it was huge. We didn't expect that because we were only thinking about making a dub plate for Bristol people to dance to, and it ended up being one of the definitive sounds of Bristol. We shot the video at the squat at St Luke's Road because that's where we pretty much started from.

Later we started to play in clubs and parties in central Bristol like, Tropic Club, Hollywood's, Mozart's and Dingys. But the nights I remember most are the ones at St Luke's Road as this was our patch and people travelled from all over to get there.

For me Bristol took the hip hop thing from New York in a different way from London. I mean London was the place to be – everything seemed to come from there. But in Bristol because of the mix of people of different races and class, we put our own unique spin on the whole hip hop culture and made it our own. Just to be part of it even if you weren't a DJ or MC, just to be part of that scene was wicked. It wasn't about individuals; it was about Bristol as a whole, everyone who was there helped put Bristol on the map and make it what it is today. ✖

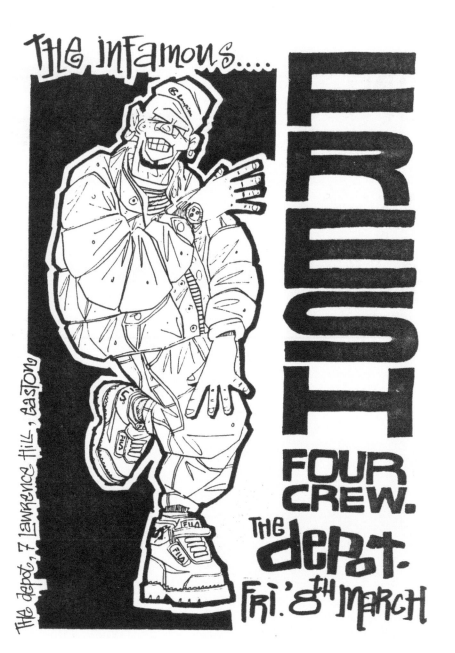

THE iNfAMOUS....

FRESH

FOUR CREW.

THE depot-
FRi. 8TH MARCH

THE DEPOT, 7 LAWRENCE HiLL, EASTON

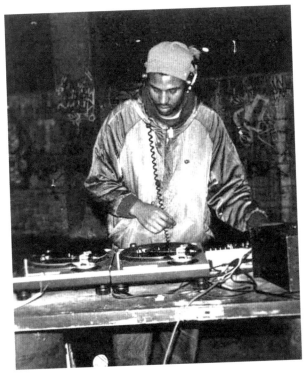

"Bristol took hip hop from New York in a different way to London. We put our own spin on the culture and made it our own..."

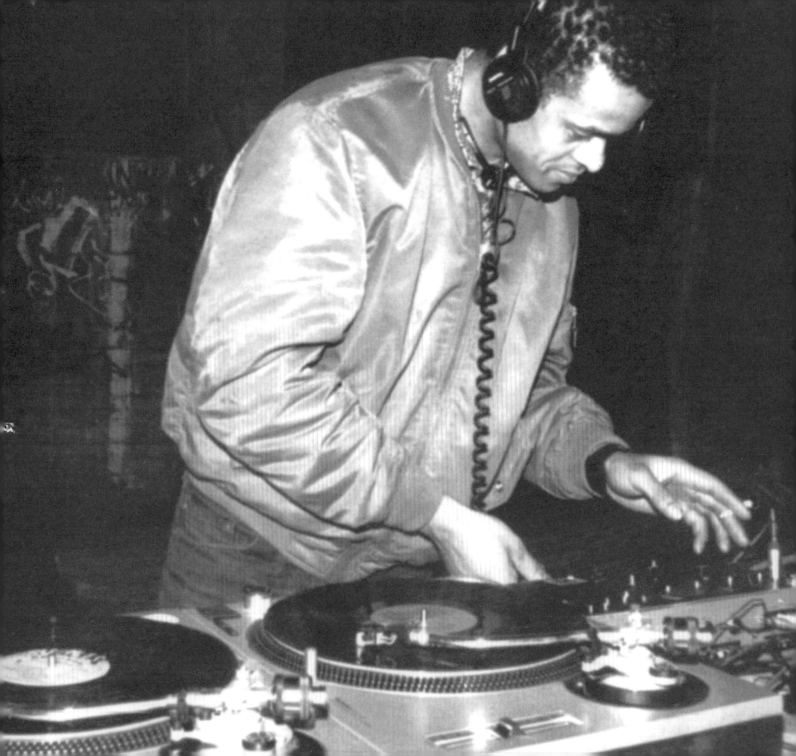

Left: Judge at St Luke's Road

Right: Sub Kulture, Fresh 4 at St Luke's Road

Far right: Fresh 4 at St Luke's Road

Below: Fresh 4 and 2Tuff at St Luke's Road

Below right: Fresh 4 at The Rummer

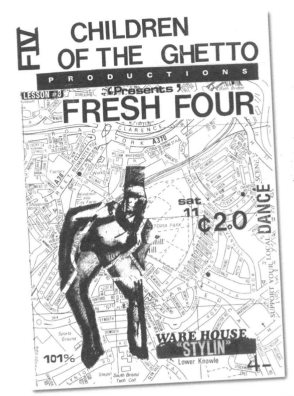

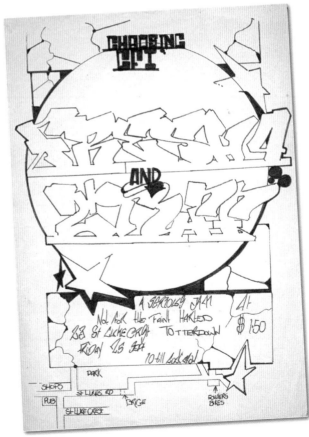

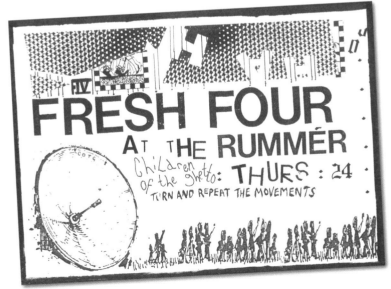

KRISSY KRISS

MC 1983 - PRESENT

An MC from Southmead, Krissy Kriss was at the centre of the party scene and hooked up with Wild Bunch and Smith & Mighty before forming 3PM and Kinsman

KRISSY KRISS

> I reckon I got bitten and hooked when I saw New Edition on some chart show performing Candy Girl and I thought, 'I can do that'. Me and my brothers where kind of living that hip hop life anyway but it wasn't called hip hop. We were travelling around going to all-night soul jams up and down the country. But what really got me to into it properly was when Tookie came back from the States, this was when we were going to clubs like Prince's Court, Cinderella's, and Locarno before it was Studios, it was soul, funk and rare grooves usually. We used to get there early and practise our dance moves in the mirror before anyone got there.

Tookie was doing some 'poppin' and stuff on the dance floor in one of these clubs and it was like 'Whoa, I really like dem moves you know!' I just had to start as well. I can't really remember the exact date, 1981 I think. But what I do know for sure was that I first picked up the mic in 1983, it was because of the 'man dem' I used to step with – Wallace, Claudio and Rookie, we all had the same sort of flavours, it was kind of organic you know, there was no rhyme or reason to it and we kind of formed our own thing down at

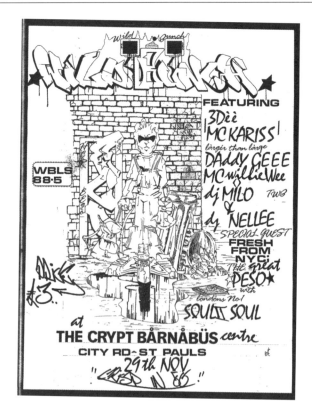

"We used to get there early to practise our dance moves in the mirror before anyone got there"

Southmead Youth Club; we called ourselves 'Crazy 17'. We did our first jam at Southmead Youth Club, it was a 'no alcohol' youth kind of thing. It was crazy because people came from all over Bristol, people who normally went to the

Dug Out and other places came over to Southmead to party. Bristol was very special in this way maybe because of the size of the city; you would just get to know people just from seeing them at parties regularly.

Z Rock crew came out of the Crazy 17 thing, which was just about 'breakin' and 'poppin' really you know, practising break dancing in the gym and having 'burn offs' with other youth clubs around Bristol. But Z Rock was more about the music; MCing and DJing. Rookie and Claudio saved up enough money to buy some decks and from then on we just religiously started buying records, going up to London to get fresh tunes that no one else had – in Bristol at that time all there was really was Revolver Records. But even back then there was competitiveness, you didn't want people to know the names of your tunes or people leaning over the decks at parties. It was like; 'ease back from the decks!'

KC Rock came about when Rob Mamuda joined us and we started to think about taking it a step further. We started adding keyboards and drum machines to our set-up and beginning to make music. This was around 1986 when my brother Rookie died. Yeah man he was a top, top DJ and could have been one of the best in the country! This kind of knocked me for six

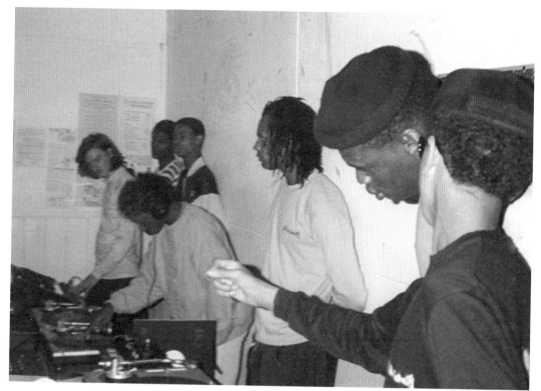

for quite a while, but then I started rapping for the Wild Bunch as well as KC Rock. Wild Bunch played in London a lot, I remember we played the Town and Country club and put on a wicked show. The Wag Club was another good gig, it was all good vibes and we were just doing the do. We'd hook up with Jazzy [Soul II Soul] in Camden too, where he was doing his 'Funky Dreads Inc' thing, well nice. But even before this Wild Bunch had their own history going way back, I mean they were doing parties in Bristol

"Back then it was rivalry but it wasn't a fighting thing, you just had to come with some skills"

for a long time, like up on the Downs and ting.

Back then it was rivalry but it wasn't a fighting thing, you just had to come with some skills! I didn't really have to battle anyone because I'd done that already, it was like; 'of course I'll come and rock with you'. I didn't think 'I'm the best', I knew I was good but it was more about just enjoying it and having a good time. In terms of MCing you had to have confidence, but I always used little tricks like looking just above people's heads in the crowd and I always had some rehearsed stuff in my head I could fall back on. I had a hint of an American accent because all the hip hop there was at that time was American, so I kind of subconsciously adopted that flow.

Funnily enough I just dug out some old DAT tapes from back then and it was all like, 'My name is Krissy Kriss, check out the flow and it goes like this'. Ha! Ha! it's kind of cringey! But I got a mix tape of me in 1984 and I don't care what anyone says it's still heavy even today! I didn't go to America to just buy garms and stuff, I was going there visiting my family and coming back with shelltops, Cazals, leather gooses, belt buckles and all that, I mean I just had to have all that stuff. I've only just given away my original Buff

jacket, shit I hope he's still got it!

Willee Wee introduced me to the concept of 'audio visuals', it was in his persona and his character, he performed the rap vocally and visually, he was a proper 'bad bwoy' MC. It was Willee Wee who in 1984 christened me Krissy Kriss, I walked into Special K's one day and he just greeted me 'Yes Krissy Kriss' and from then on every one called me that. I mean Special K's was 'The' place, it was just a melting pot you know, if you needed to find someone you would just go there and they would turn up sooner or later, if you needed to find out what was going on that weekend you would find out there, of course this was before mobile phones and internet, but you could get all the info you ever needed at Special K's.

Flyers were a big part of the scene too; you wouldn't even need to read it properly all you needed to know was where and when; 'those in the know, know!' I mean if Ego, Inkie, Felix, or 3D did the flyer then you would just automatically know it was gonna be a decent party, but you as a crew had to warrant that because they wouldn't do flyers for just anybody.

I've got so many memories of wicked jams that it's difficult to put the weight on one, but through the years, rocking at the

Crypt (St Barnabas/Malcolm X Centre) with Soul II Soul & Peso was bad boy; the Redhouse party when Newtrament came down was wicked and when 3PM supported Greg Osby at Trinity. The house

party I really remember the most was Phil's [FBI] birthday party on Hampton Park, Redland, this was devastating, but to be fair all them house parties in Redland were proper heavy in them days. I also remember one Wild Bunch jam in London when it got raided. It was some underground place, wicked set-up. There were police and people everywhere until only Bristol peeps were left cos we had to wait for the coach. I don't think the police were used to having a bunch of Bristol heads all in one place; nuff words spoken, put it that way.

The thing is, all I can do is relate to you what I remember, from my perspective. There's nuff people in Bristol who I consider unsung; on a DJ tip I'd have to salute Milo and The General cos they bad; for subtle inputs and involvement with a lot of successful bands and artists, it's Basil Anderson; singer/songwriter Carlton cos he's been down from time and for artwork it would have to be Mark Barnaby (Barney) his freehand work is wicked.

Simple tings – one day Dave McDonald contacted me and asked if I'd be interested in doing a guest appearance on a tune by Rob & Ray [Smith & Mighty], I said that it would be cool and that was that. I eventually hooked up with Kelz

and Lynx and ended up recording the **Anyone** track featuring Jackie Jackson. Through this we done nuff shows touring up 'n' down the country and across to Europe. During this time, Kelz, Lynx and me decided to form our own crew and 3PM was born – 3 man Posse Move. We recorded an album's worth of material, had several 12-inch releases and appeared on a few compilation albums. We still see each other occasionally; Kelz is still rhyming strong and doing his Souljah Clique thing, Lynx is still DJing and producing tunes and I'm on the Kinsman tip which is still moving forward. It started when I hooked up with a guy called Longlastin, a wicked producer who dropped some serious future funk and got together a band to perform the songs live. This went well, gigging at a lot of festivals too, big up to Vee (Virginia) for her sweet vocals and to Paul Raymond, an essential part of the band.

In the early 90s I set up an organisation called BHGM (British Hip Hop Ghetto Movement). It was called up to encourage hip hop in the UK and recognise that British hip hop had its own history. Crews were in contact a lot more then and flavours were flying high. Under this banner I managed to arrange monthly jams, inviting crews and individuals to come and perform their latest cuts. The night was called B-boys' Delight and

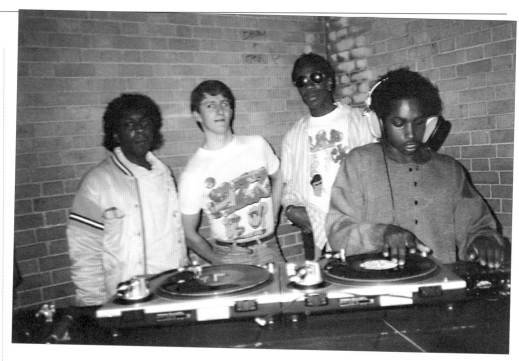

crews like Blak Twang, Transcript Carriers and Numbskulls done a set there. It was a really good hook-up. People got involved and really supported it. The Visual Graphics guys were up for it (big up Kilo); MCs would catch up for the open mic; graff artists would exchange pictures of pieces and peeps would help distribute flyers; Shade 1, Jay and Barney hooked me up with the artwork, it was realisms. Now, I'm working on new material, so I guess it's watch this space... (www.onekinsman.com) ✖

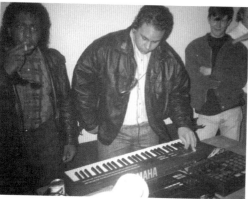

Left: Z Rock's first party at Southmead Youth Club by Krissy Kriss, 1984

Top: The original members of Z Rock at their first party; Wallace, Claudio, Krissy Kriss and Rookie at Southmead Youth club, 1984

Above: Wallace and Rob Mamuda on the keyboard (KC Rock) with Dom T (2Bad) looking on at Dingys, 1986

Manfred was always a musician first then a DJ later, after moving to Bristol in the early Eighties he became fascinated with the skills of some of the DJs here. He became a fixture at the Dug Out and Moon Club playing funk and soul

DJ MANFRED
1985 – 1991

DJ MANFRED

RDA FAMILY AFFAIR PRESENT: a festive freestyle

St.BARNABAS CENTRE (MALCOLM.X BUILDING)

FRIDAY 30TH DECEMBER

FEATURING

UD4 and Manfred

ALONG WITH

FBI Crew DjBunjy WITH Sister-C.

12untilDawn

£1.50 BEFORE 2am £2.50 AFTER 2am

" I was an instrumentalist before anything – I was a musician. What got me into hip hop and electro was when I was 15 years old in about 1980 living near London. We could just about pick up the signal from Capitol Radio and I remember hearing one of Tim Westwood's first shows on there. I started listening to this stuff all the time as it was brand new and at that age you're open to any influences.

I loved the music and everything else that went with it, but I didn't know much about DJing until I moved to Bristol in 1984. That's where I saw people doing things on decks that really fascinated me. I was lucky enough to have a bit of money which not a lot of people had at that time, so I went out and bought a pair of Technics. Word got around that I had decks, to the point of someone saying to me: 'Let me borrow your decks and I'll let you play at the Dug Out club on Saturdays' so that sounded like a good deal. I played there for about a year until it closed in 1986/7. We obviously played a lot of hip hop at the Dug Out but we also played what we called 'Club Soul' which was stuff like, The Conway Brothers, Loose Endz and even Cameo, this stuff was fresh and brand new at the time as well. A lot of crews like, FBI Crew and 2Bad were playing this stuff too. I then got a residency at the Moon Club for about three years. I think I played there three times a week.

I didn't play at many house parties but I do remember playing a few tunes at Daddy G's birthday party on Campbell Street, St Paul's. When I first came to Bristol it seemed like I went to a house party every week. This was when most hip hop DJs in Bristol didn't have any spots at clubs, so house parties and warehouse jams were the only places they could play.

The first people I met from this scene was UD4, I remember a party at the hall of residence at Bristol University where all we had for a sound system was a Ghetto blaster and Damon was rapping over that, he was actually under the table because he was too embarrassed to show his face. But what really blew me away about UD4 was The General; he was switching back two copies of a break beat 'Grand Master Flash' style. I was just getting into DJing at this point but all I was doing was mixing, The General was

on a different level. That's when I thought, I've got to do that, but I never got anywhere near his level.

I remember when I used to DJ at The Rummer, they had nothing in there, we had to first hire a rig, lug all the equipment down that narrow staircase down into that grimy basement and actually build a table out of scrap pieces of wood to put the decks on. But it didn't feel like hard work, that's what you did in those days to get a party together, we were young and a good group of guys, we all loved listening to the music and that's what we wanted to spend our time, energy and money on, it was all we did, it was our life. And some of the people I met in those times are my best friends forever.

That special time in Bristol was as much about people in the city making their own particular brand of music as the party and graffiti scene. I started hanging out with Rob Smith (Smith & Mighty) not long after coming to Bristol and the stuff they were making back then blew me away.

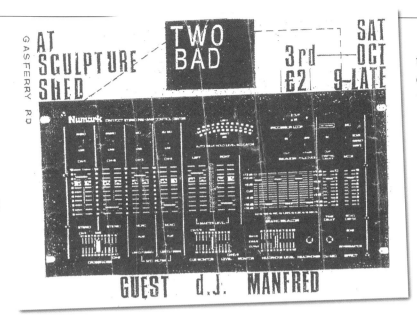

Previous page 85: RDA Family Affair by FLX, 1989

Left: RDA Family Affair by FLX, 1989

Above: 2Bad and Manfred at the Sculpture Shed, 1985

"We all loved listening to the music and that's what we wanted to spend our time, energy and money on..."

I remember when Rob gave me their first test pressing of **Anyone** and I played it the Moon club that night, this was a really special moment for me, I will always remember that night.

There are a lot of people that have come out of Bristol and gone on to superstardom and quite rightly so, but I think that Rob has always been there constantly doing his own thing and not been catapulted into fame and all that, I think he deserves it because creatively he's up there with the best. He just keeps going, keeps developing musically and keeps getting new audiences – reggae for the 21st century!

I love DJs and I think hip hop DJs are very creative people. But there's a big difference between playing and mixing up tunes. To take the time to learn how to arrange and make music that sounds good, that's a real skill. See, I'm a musician really and DJing although I love it, was a kind of bi-product of me being a musician. I was in bands and I've worked with bands, it's really hard work for sometimes very little gain.

I did have an excursion with go-go music and I'll challenge anyone who's got a bigger collection. I even went to see a few live bands that came over from the States; I mean the Chuck Brown gig was unbelievable. To me some of the rhythms were irresistible and very infectious. In the later Eighties I got back into hip hop a lot more. This was the time Big Daddy Kane, Biz Markie, Just Ice, Public Enemy, Eric B & Rakim and EPMD were putting out a lot of records and I got the feel for hip hop again. ✖

DJ MILO

WILD BUNCH
1979 - 1989

One of the major influences in the UK hip hop scene, pioneers of the subculture, Wild Bunch would go on to define an era and create and influence many other artists, musicians and sounds

DJ MILO / NELLEE HOOPER / 3D
DADDY G / WILLIE WEE / MUSHROOM

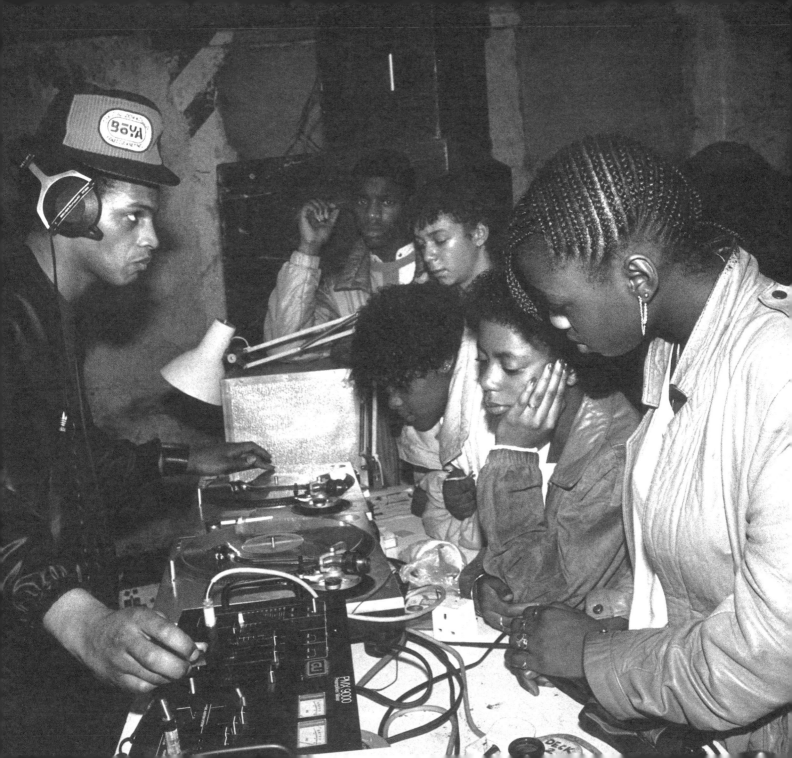

TOKYO FRESH '89

JUNGLE BROTHERS · DJ RED ALERT → FROM NEW YORK
THE MASSIVE ATTACK → FROM LONDON
MAJOR FORCE POSSE
NG! PRODUCTIONS posse

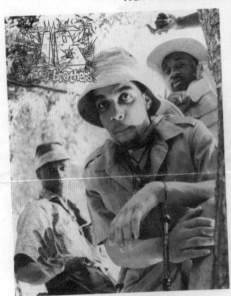

DJ RED ALERT

M.C. 3-DEE MILO

the massive attack

MAJOR FORCE POSSE **NG! PRODUCTIONS posse**

次回予定 **TOKYO FRESH '89** VOL.2
⟨5/3·4·5 45KING 他⟩

INK STICK 六本木 *CLUB* *INK STICK* 芝浦 *FACTORY*

4月6日 (木) 開場/7:00P.M. **4月7日** (金) **8日** (土) 開場/6:00P.M.
 開演/8:00P.M. 開演/7:00P.M.

[4/6·7·8共に前売●¥4,000(1 DRINK) 当日●¥4,500(1 DRINK)]

主催:SEC CORPORATION 企画制作:TANAKA PROMOTION 協賛:**SHARP** 問い合わせ:TANAKA PROMOTION (03-486-8071)
SPECIAL THANKS:SOMI HONGŌ HIROSHI FUJIWARA KAN TAKAGI Rhythm Method Funken Klein

チケットぴあ☎03-5237-9999 インクスティック芝浦ファクトリー☎03-798-3921
チケットセゾン☎03-5990-9999 インクスティック六本木クラブ☎03-401-0429
丸井チケットガイド☎03-363-9999 レッドシューズ☎03-499-4319
DEP'T 各店 ミントバー☎03-403-1537
 チケットお求め先

DJ MILO

"I think the first time the Wild Bunch played was at the Green Room near the city centre, not sure of the year maybe very late 1970s or early 80s but it wasn't really a punter type affair, more of a posse gathering. It was just for close friends really, on a not very good system but it was louder than your home stereo and that's what counted at the time. Not sure of when it ended, I know I was in Japan doing some stuff with Major Force, I came back knowing that I was probably moving to New York after getting married, but it never really dawned on me that it was the end of the crew. There were a few things that went down that I won't go into that put a bit of distance between some of us, just people bullshitting which I just got really tired of, but nothing major.

From a personal standpoint I don't think the Wild Bunch ever really died in concept, I have always played as if I were still in Bristol with the people of my roots and that will never end as far as I'm concerned. But in a physical sense I think people see the Wild Bunch as Nellee, G [Daddy G] and myself in front of the turntables. But musically I would like to think that it's still alive. I did a mix CD a while back for a company called Soph

in Japan and when I finished it and listened to it, I just thought to myself, this is exactly how I imagine our sound to be if we continued playing in Bristol without any diversions.

I can't really remember when we started playing hip hop, but it was early 80s the first 'Enjoy' stuff springs to mind. Why did we start playing it? Because it was dope! It was an extension of what I think a lot of bedroom DJs were doing at the time which was pause button mixes on cassette extending the favourite parts of songs on your basic home stereo. That whole concept at the time was sacrilegious to musicians and I understand it now, but it was pure punk in ethic to me.

Everything influenced me at the time and I've said it numerous times, it gets kind of a little bit corny, but there's nothing fake about it at all. Our generation was fortunate to experience the dawning of so many new musical styles that previous generations and

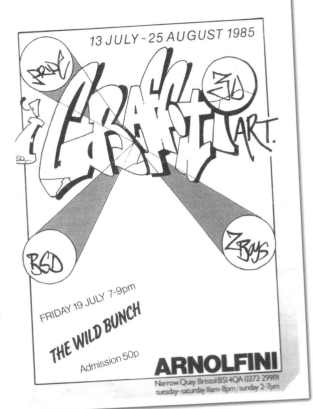

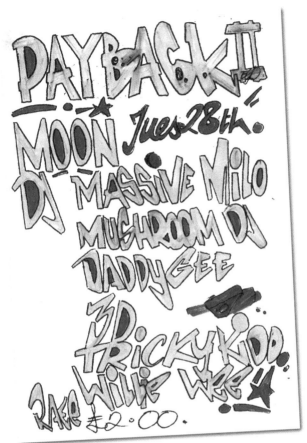

"Our generation was fortunate to experience the dawning of so many new musical styles"

future ones would never experience. We had the disco, punk, and hip hop era and those three were not just fads they shaped everything we hear today. Not only that, growing up I had reggae or ska,

soul and folk stuff that my mother listened to. I think going to the Prince's Court for the first time and hearing a DJ called Seymour was life changing for me. He just played what he liked for the most part but it was really incredible music that I never heard before. I think another influence early on was a friend I had called Duncan who had a really incredible collection of punk stuff, I mean

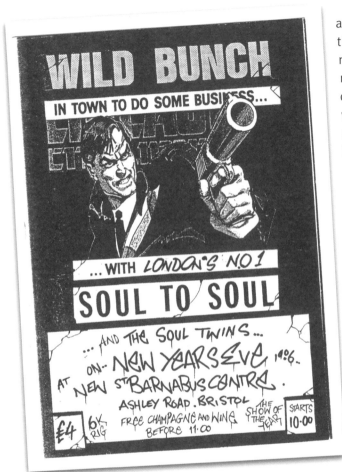

almost every record and from that I got to hear some incredible stuff too. I think Dunk was the one that made me into the type of person that just wanted the best and rarest records.

In terms of artistic development Bristol played a huge part. Basically, I came to understand that we are unique as a city and we produced a sound that was unique, make no mistake about it. I didn't really think about it before, only recently. Yeah I mean it was special to me, I can't speak for anyone else, but for me looking back I think Bristol was at its creative best. To a degree Tokyo played a part in my development because it just opened my eyes to the fact that they were ahead of the UK in the hip hop scene. When I went there they had already had the Wild Style Tour, I got given a video tape of that tour that blew my mind at the time. On the music level they were also ahead. I also found some Devastators in Japan. When I thought of Japan I imagined buying a wicked Walkman and that was it, but when I saw the records and the sneakers I just couldn't believe it. I called Nellee up the day I got there and told him about it. I think I came back with untold sneakers from my first trip that Neneh (Cherry) set up.

The other crews like FBI, UD4 at the time sucked ass! Ha! Ha! Ha! Just joking –

they know that. We loved anyone. They respected us as a crew and those two crews in particular always gave us much love. I didn't get to see so much of UD4 play out at the time, but I was really proud to see what they became later on with their musical careers. FBI were really good, I think they were my favourite crew in Bristol at the time, wicked selection every time and tight technically.

We didn't battle any other crews in Bristol really. We had a really friendly type of battle with Newtrament in the Redhouse jam. But Newtra and the Ladbrooke Grove crew were partners of ours so there was no tension at all. I think the only time we had a bit of tension at a jam was in North London, Ruffneck area and it was where we first met the Soul II Soul crew in their early days. Anyway, there was this local crew playing as well and we as a crew just really never played second fiddle to anyone and these guys were unplugging our set when they thought we were controlling things, it never got nasty but I got heated when I caught one of

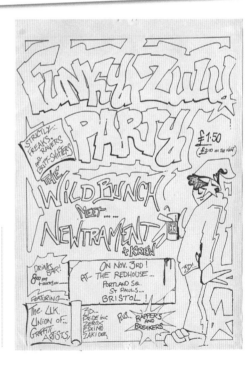

featuring **the wild bunch**

LONDON TOKYO NYC

introducing **the massive attack**
dj milo, 3 dee, dj mushroom, daddy gee
tricky kidd and willie wee.

these guys grabbing the power cable. It was all love and we all made it back home in one piece.

The social state of Bristol definitely played a part in the hip hop scene. To quote Pop the Brown Hornet… "Everybody out here poor". That was the case – we all were in the same boat socially which is why the UK is Number One. In the States you can have poor blacks and poor whites and they will be completely at each other's throats like crabs in a barrel, but in the UK we were more unified. I don't know if that's the case now;

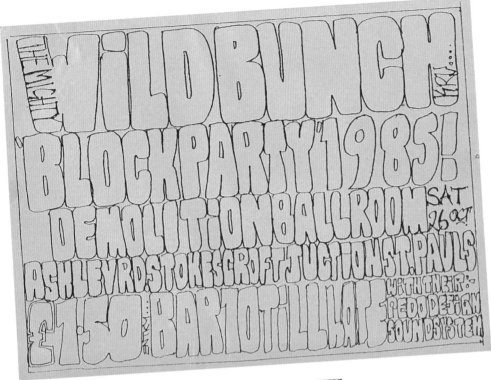

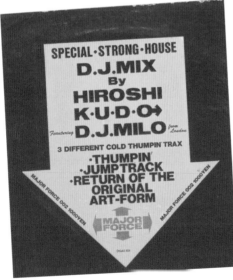

> **"In terms of favourite parties, St.Paul's Carnival was heavy duty – those were the best for me"**

because I haven't been able to hang out for any length of time to really see what's going on.

In terms of favourite parties, St.Paul's Carnival was heavy duty – those were the best for me. A lot of people enjoyed the Red House jam because it was Bristol's first warehouse party. The St. Barnabas jam on New Year with Soul II Soul was special. There were a lot of good parties. The Clifton house parties were also good. The FBI crew did some nice parties, can't remember where or when but they were good quality sets. The only crew that I think we looked up to in the UK were Mastermind, they were incredible.

I didn't think being a DJ was a career back then, not at all, it was fun and the money was just a bonus not the goal. Not for me anyway, that's why I'm broke now! Ha! Ha! Ha!. What I do now is pretty much a natural progression. I don't force anything on myself I love making music and I'm getting more disciplined in my approach to making it consistently, but I refuse to make it something to pay the rent. I want to keep it as pure as I can, because relying on it that way would ruin the integrity of the music I make. Flash, Marley Marl, Hashim etc all inspired me in a way even though what I make now is not really classed as hip hop. I think Flash on those decks in **Wild Style** was monumental for any DJ in the UK. I loved

the early stuff like the Furious 5
but especially Kool Moe D, one of the
greatest rappers of all time, Love Tribe,
Grand Puba, P.E. and many others. Too
many to mention really.

I think the flyers were important
because it gave people an idea of what
they could expect in terms of quality. We
just saw what they were doing in New
York and thought that would be wicked if
we did that for our parties. The thing we
didn't really take into consideration
is that the majority of the people who got
the flyers never saw that idea before
because they weren't privy to the inner
runnings of the NY hip hop scene.

I don't really follow the graff scene like I
used to, especially in the UK, I'm not
really as up to date with the goings on
in the UK as you may think. Over here in
NY I have a digital camera with me all the
time so I take pictures of any good graff
that I might see. I have just restarted the
selection process of tracks for a
new album and will begin searching for
singers for the tracks. I got about three
mix CDs in the works and after many
years of procrastination have finally got a
website up (www.dj-milo.net). I
will probably put some limited singles out
first before the album, just tracks not
related to the album material but club
tracks. ✖

Left above: Demolition
Ballroom, Wild Bunch Block
Party 1985

Left: 'Thumpin' by DJ Milo,
Hiroshi & Kudo Major Force
Records (Japan), 1988

Above: Wild Bunch, 2Bad,
F Zone and Z Rock at St
Barnabas Centre, 1985

Right: Wild Bunch Xmas
party at Grosvenor Road
by 3D, 1985

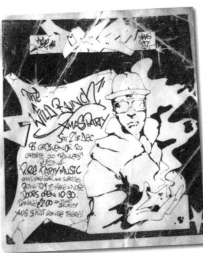

PART 3 At BarnabaS
July 5 85
$ 2 · 0 0

WI·LD
BUnCH
2BAD
fZONE
ZROCK

10 pm

rocking in
a
more Profound
manner

PLUS ONE CREW

1983 – 1986
(B.I.G PRODUCTIONS 1986 – PRESENT)

Coming out of St Paul's, Plus One brought the blues club vibe to their nights, no gimmicks; they loved to keep that raw DJ and MC element at the forefront of their jams

DJ STYLE
WILKS
RONI SIZE
FAGAN

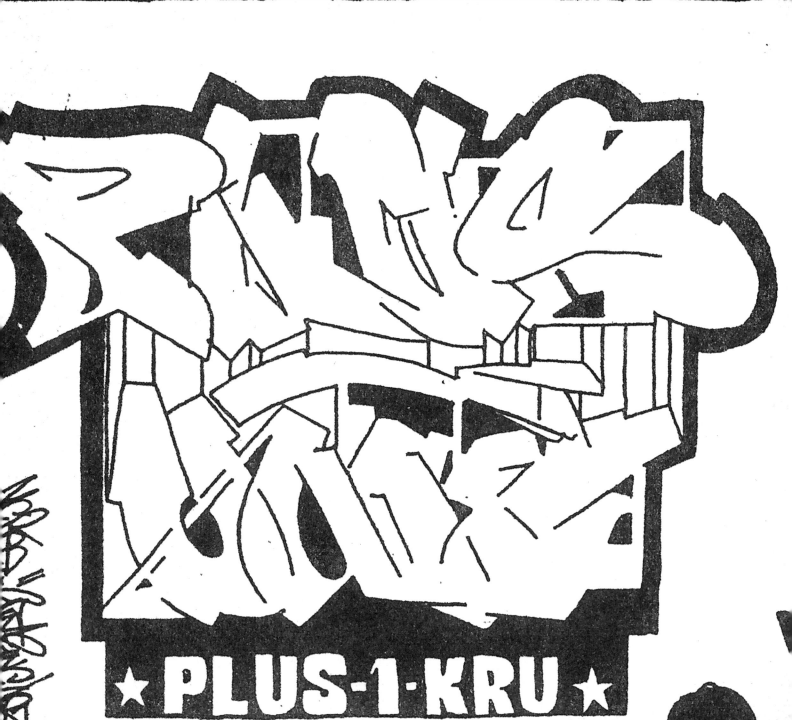

★ PLUS·1·KRU ★

DJ STYLE

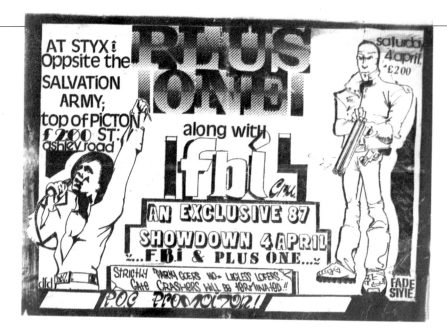

> I got into the DJ thing from going to jams organised by the legendary DJ Superfly featuring the likes of Jazzy B (Soul II Soul) and Wild Bunch. In those days Tim Westwood and Jazzy B would come and study the Bristol scene way before they were household names. Superfly was the first black radio presenter on BBC Radio Bristol and was given 15 mins airtime! He used to play funk, soul, reggae and disco. He also used to promote the Bamboo Club in St Paul's, where among others Bob Marley played at in the late 70s. Another top DJ of those times whose tapes I used to listen to was Dennis Richards

I got into the Plus One thing hanging out with my school friend Wilks, who was the originator of Plus One Crew along with Roni Size. We were just a family of people, a posse, Plus One Posse, stemming out of St Paul's. Then Jason Geake and Steve Pang who went on to become The Wise Guise, joined up with Plus One. Before then we used to go to Sefton Park and hang out with Roni and his brother Andrew (General of UD4) and spin tunes around their house. We hooked up with F.B.I Crew for a few parties, then myself and others set up R.D.A (Real Deal Artists) with FLX (F.B.I/ Crime Inc) and Inkie, and did workshops in youth clubs demonstrating the different forms of hip hop culture. I was also painting with Fade (Lee Jordan), our graffiti crew was Design For Desire (DFD).

For me everything came out of the days of the Dug Out club, house parties in St Paul's (Campbell Street/ Argyle Road) and jams in the Redhouse, The Granary, and The Crypt at The Malcolm X Centre, where Wild Bunch along with Newtrament put on one of the heaviest nights of all time! We used to go to all these jams and it was just so new and fresh, it was a mix of people from all areas of Bristol jamming together. There would be the odd bit of trouble, but it got resolved. Generally it was a bubbly atmosphere.

Back then it was all about the DJ and MC element at parties, I would go to a jam and get straight over to where the DJ was and watch and learn. If his mixing was off or his scratching was wack everyone would let him know. It's not like now when you go in a club and you don't even know where the DJ is let alone see him mixing. You had to be fresh and it was consistency that kept you in the game. The 'healthy' competition between crews and even between DJs within crews was good; it kept you on point and encouraged you to always try new things.

I remember Plus One doing the now legendary jam with Sweet Beat, a crew from London, below Frontline Video in about 1986 – it was just bass lines rumbling through the walls all night.

Parties were about sound systems, this came from the dub sound systems era, the bass from these systems had to able to shake the floor and rattle your chest.

At the St Paul's Carnival from the mid 80s, Wild Bunch would control the top of Campbell Street with speakers piled high towards the heavens, DJ Milo and Nellee controlling the crowd with Willie Wee on the mic. These were times to remember.

Pirate Radio played a big part from Radio Luxembourg, Bad Radio F.T.P down to RAW FM, where I DJed. My show was after Roni Size on Friday night 8-10pm. I use to listen to City Rockas and the 2Bad Crew on Emergency Radio in the late 80s.

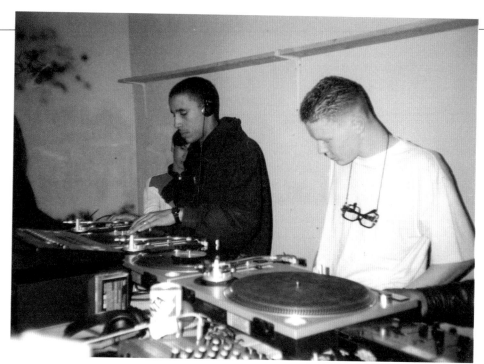

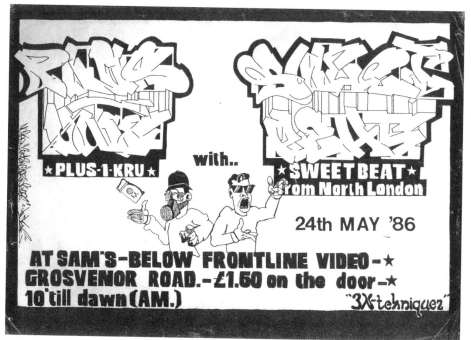

★PLUS-1·KRU★ with.. ★SWEET BEAT★ from North London

24th MAY '86

AT SAM'S-BELOW FRONTLINE VIDEO-★ GROSVENOR ROAD.-£1.50 on the door-★ 10'till dawn (AM.) "3X-tehniquez"

The crew I'm in now is B.I.G (Born In the Ghetto) Productions along with Fagan and Wilks. This grew out of Plus One, Wilks is now a recording artist. We have residency night at Cosies, and do nights at various nightspots and bars. I host a show on local station Ujima Radio 98fm, Saturday 8pm-10pm (Code of the Streets) and DJ Fagan is on air Wednesday between 8pm and 10pm spinning upfront exclusive, local artists and of course the old school classics paying homage to where we started. ✖

Previous page 97: Plus one by Crime Inc Crew, 1986

Far left: Plus One and FBI at Styx by Fade and Style, 1987

Left: Plus One and Sweet Beat at Dingys, 1986

Above: Wilks (Plus One) and Jason Geake (Wise Guise) at Dingys, 1986

PRIME TIME

1986 - 1993

**BENJY TONGE / STUART RANKIN
DJ APOLLO / SAM TONGE**

You were guaranteed to have a good time at a Prime Time night – they played at most of the popular underground clubs in the city but house parties were also their thing. They embraced acid house and it became their main sound

BENJY TONGE

" We started out at school where we all knew each other, Stuart was in the year above us and Sam was two years above us. We got into the DJ thing through *Wild Style* and *Style Wars*, also through hanging out at the Friary Café, which Stuart's dad owned at the time. There was a pool table downstairs and we just hung out. Inkie Felix, Paul Cleaves and Phil Jones (FBI Crew) hung out there too. But mainly we got into it because of watching DJ Milo; he was the 'Man'. He just seemed so cool on the decks, because at that time there was a lot of pressure on DJs because that was usually the focal point for the party. I remember at Demolition Ballroom or somewhere he was on the decks eating a chocolate bar and would put the bar on the record while it was playing, look through his crate of tunes then pick up the bar just in time.

Back then the scene was really competitive, I remember the Wild Bunch always giving us a hard time. They wouldn't let us into some of their parties. I was really into beatbox and I remember Nellee saying to me to come to their base and put down some sounds. I remember when I got there a few of the other members of the Wild Bunch came in and were like 'what the fuck did you let him in

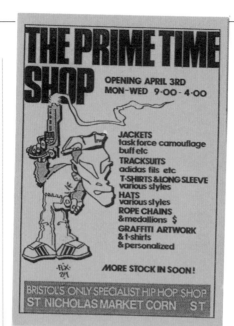

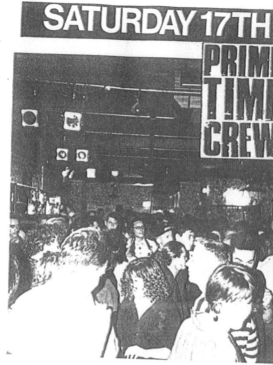

here for', and that was that.

I remember the first party we did was the Cotham Jam at our school. I remember the teacher saying that they had not organised a school disco that year (1986 I think). We said we'd do it, not really thinking that they would say 'Yeah!'. We got a system and someone on the door even though it was only 40p to get in! There was also a rich aroma of weed which filled the corridors of the school that night. I also remember the Anchor Road Party (where @Bristol is now) we did with FBI Crew. We even tried to charge people to get in but we had to abandon that idea because there were three open sides to the building and people could just

jump over the 3ft railing. The police kind of just left us alone; I even remember the police helping us start the generator when it packed up.

One of the best parties we did was on Hampton Road, Redland; this was just a dark basement with the decks under the mattress-clad windows and people wall to wall. Back in those days there were so many student parties going on in Redland, Cotham and Clifton that a lot of

"There was also a rich aroma of weed which filled the corridors of the school that night"

them got rushed by people from all over Bristol, who would then just take over the party. Some people even started to charge the students on the door to get into their own party! I also remember Bristol Bridge Inn, we had a night there every Friday, I think it was our first regular spot. This was always a good night, where you could feel comfortable and jam till the early hours in the centre of Bristol, which was rare in those days as clubs in the centre were not too interested in hip hop and house. I remember the Thekla as well, every weekend it seemed that something big was happening. I have good memories of playing with the Jungle Brothers there in 1988 or 1989, which was a wicked night. We all got signed copies of their tunes. This was good because there weren't many big US names coming to Bristol at this time.

In around 1989 we got into other things. We opened a shop, first in St Nicholas Market called The Prime Time Shop and then on Colston Street called Tribe of One which had clothes upstairs and a record shop downstairs, I still have really good memories about that place.

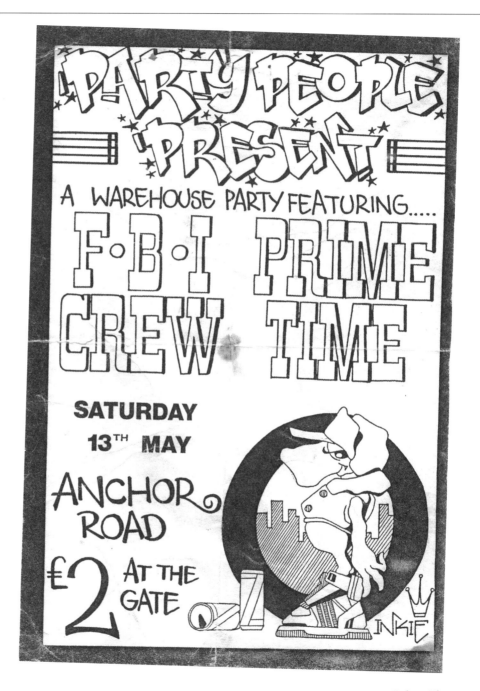

DJ APOLLO

I was 15, and after I'd broken my dad's belt drive turntable experimenting with scratching, he was like 'what the hell are you doing?' it was because those beautiful Technics 1200s were on the scene, I was obsessed with them. My dad, bless his soul, bought two of them, one for me and one for my brother, I'll never forget the day bringing them into the bedroom it was like every Xmas rolled into one, the adrenaline rush from just touching them for the first time was awesome. Every day after this I'd wake up, have half an hour with the headphones on before I went to school, then at morning break at school I'd run down the hill to have 15 mins on them, then I'd be there all lunch time and straight after school. I only had a Realistic mixer with no cross fade so I used it side-ways, I was just so obsessed with scratching!

Prime Time Crew happened because me and Benjy went to school together and were best buddies, and when I got my decks he was a fixture round my house along with his brother Sam, at one point we had five decks set up at the same time. Sam, by the way, even though he was known for being a House DJ was the

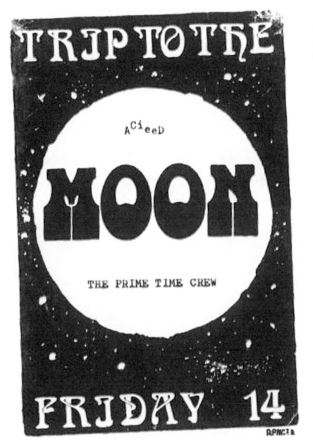

"I only had a Realistic mixer with no cross fade so I used it sideways, I was just so obsessed with scratching"

best at cut scratching I ever heard, not many people know that!

Some of the things that turned me on to scratching were of course Grandmaster Flash and Marley Marl, but when I heard DJ Cheese at the DMC world mixing championships against CJ Mackintosh, that just blew my mind! And after that I spent the rest of my time trying to do what they could do. After about a year practising, Paul and Mark Cleaves [FBI] were saying to me, 'you got to start playing out'. Then we did that party at Cotham School in late 1986 I think, Grant Marshall, Willy Wee and Nellee Hooper [Wild Bunch] turned up at the party and I remember thinking, 'Oh my god what are they doing here', I felt really nervous.

The big defining moment for me being a DJ was when I played at St Paul's Festival on Dennis Murray's [Dirty Den/Easy Groove] set up. Wild Bunch's set was on Campbell Street and Dennis's was on the next street down, and Wild Bunch's system failed or something, so a lot of people came to our set up. I remember Benjy and Sam passed the headphones to me and I thought 'Hang on a minute, I thought you were the big dogs' but I grabbed them anyway and put on a Chicago house tune, I think it was an old

Trax tune and the needle kept jumping, and all I could hear was, 'get that honky off the decks!' But I mustered up some courage and after changing the phono leads around on the mixer, I got out 2 copies of Run DMC's **Peter Piper,** and turned that tune inside out, upside down and all over the place, the street went crazy, there were well known MCs fighting for the mic! And from that day onwards my confidence just went through the roof.

I remember playing at the Moon Club and Krissy Kriss, getting on the mic, I mean he was one of the original B boys back then, he had the leather bubble goose, the shell toes, the belt buckle and of course the skills on the mic. He just started doing that slow rap that he used to do over the top of me mixing up and it just sounded wicked. And that's how I got to know Krissy, we ended up doing the stage at Ashton Court festival one year. That was when I felt like a star, thousands of people at this event and I was on the stage entertaining them. You got to remember that DJing back then was still very new and to have a DJ and MC on stage at a big festival event was kind of groundbreaking.

Willy Wee used to do some stuff on the mic at our parties sometimes, and that guy was just so natural on the mic, he would make me smile because he was just so smooth! For me these guys, Willy,

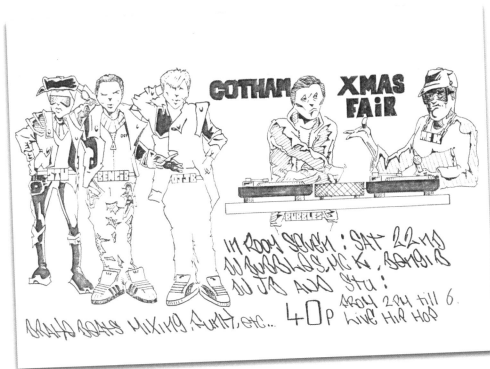

Krissy and Kelz too were just about the best MCs in Bristol at the time.

When house and acid came in I was well into it and it became my passion, but I would always love to scratch up an acapella over the top of house and techno tunes. I tried to make my scratching sound like a musical instrument, and doing my sets I would always start with scratching, you know, kick it off properly, and start how I meant to continue. ✖

Page 101: Cotham jam by Nick Walker, 1986

Page 102 (left): The Prime Time Shop by FLX, 1989

Page 102: Prime Time at the Moon Club, 1989

Page 103: FBI and Prime Time at Anchor Road Warehouse by Inkie, 1988

Left: A Trip to the Moon; Prime Time at the Moon Club, 1988

Above: The Cotham Xmas Fair at Cotham School, 1986

SMITH & MIGHTY

1983 – PRESENT

They seemed to influence anyone who came in contact with them or just heard their music. Their fusion of hip hop beats and reggae bass lines is legendary and they continue to re-invent music today

ROB SMITH
RAY MIGHTY

9 *TIL LATE*

WILD BUNCH
·
2 BAD
·
CITY ROCKERS
·
Def Con
·
HIS MAJESTY
·

SMITH & MIGHTY

LARGE SCREEN VIDEO, FILM & SLIDES

PROCEEDS TO THE A.N.C

BRUNEL SHED.

St. Pauls
APARTHEID
Free ZONE

ROB SMITH

" I got into the whole thing through reggae music. I had an apprenticeship after I left school at Rolls Royce, I did four years and realised I hated it. I really wanted to get into music and the best way I thought was to buy a guitar, so I bought one. In 1981 I put an advert in Revolver Records saying 'guitarist looking for a reggae band', some guys turned up, we had a bit of a jam and I actually learned how to play the guitar with those guys. Then this thing called Arts Opportunities came up in St Paul's. Me and a friend went down there and got a job on £22.50 a week! There was a sort of musical and we were the band called The Zion Band or something, we even toured Europe. Before this I was mucking around with splicing tapes together to make music, but I really learnt how to make music through all of these experiences. I bought an echo for the guitar and when I heard it, it really had an effect on me and I thought wow! It took it to a different level musically.

I met Ray a little after the Arts Opportunities thing. There was a band at the time called Sweat and they asked me to join. There was this moody guy on the keyboard with dreadlocks. When the band

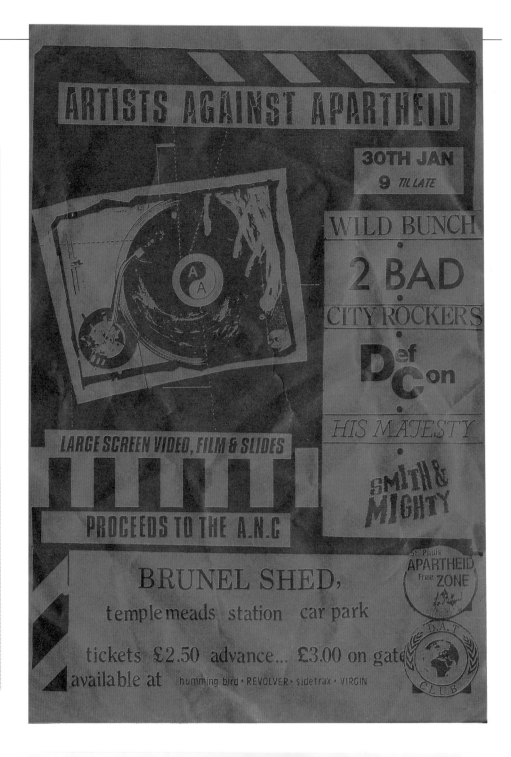

split up we both realised we had similar interests in sequencing and we went from there. The idea was to put a record out, so we got our label together [Three Stripe]. I kind of fell into producing music, we started to get our studio together on Ashley Road and we bought a mixing desk, drum machines and different types of gear. Then a few people who were hanging out with us and were interested in making music like Peter Rose, Kelz and Krissy Kriss started coming round, we put some beats down and people seemed to be into it. We knew we were all right and we were having fun with it. One of the guys from City Rockas went to London with our tune **Anyone** and when he came back he had this look on his face that I'd never seen before, he was saying, 'You guys don't know what you've got, you won't believe the effect your tune's having!' and we couldn't believe it, and it blew up from there.

We didn't realise we were creating something, because reggae music and the dub element in particular was always what I was into, but Bristol was into hip hop at the time so we were mixing the two styles together in our own original way. Then we were both having memories of when we were kids listening to all the Bacharach and Dionne Warwick stuff, we were noticing all the reverb and echoes going on the production of that music, some of the sounds going on in that music were quite ethereal. Although it was quite poppy it had a kind of dub element to it. We just put out loads of the music we liked and influenced us in our music, we liked reggae bass, hip hop beats, and some nice vocals, we didn't really plan it, we just liked the music and that's what came out.

In terms of collaborating, it was kind of just through people coming round. We needed a vocalist and I knew Jackie [Jackson] from the Arts Opportunities thing. We asked her to come round, found out she could sing some Dionne Warwick stuff, we did **Anyone** and **Walk On** on the same beat in the same day, we did different mixes for each track.

For me it was always the 'dub' thing, about separating the sounds so you could put FX on them individually and it took a while before we were able to do this, it took a lot of experimenting. All I really wanted to do was make dub music. It wasn't until we got a few DJ spots and were doing PAs that we hooked up with the Wild Bunch. The Anti-Apartheid party at Brunel Shed we did with loads of other crews including the Wild Bunch was memorable. ✖

> ## "For me it was always the 'dub' thing, about separating the sounds so you could put FX on them individually..."

Page 107 and left: Artists Against Apartheid at Brunel Shed, Temple Meads, 1988

Above: 3 Stripe and Triple XXX at Malcolm X Centre

UD4 CREW
1983 - 1988

ZION / HEALER MC
SPIDER / THE GENERAL

Boasting The General, one the best DJs in the city, UD4 were a confident and assured crew. With a reputation built on house parties and spots at the Dug Out, Moon Club and Granary, they were prepared to take on anyone and everyone...

ZION

> Me and Alistair were friends and were into MCing – we were called the Dynamic Duo. We knew Delroy and Andrew, they were two or three years deep into breaks and DJing already and were called the Ultimate 2, so when we joined up we called ourselves UD4 (Ultimate Dynamic 4).

The first time I experienced battling other crews was when Wild Bunch had a thing on Saturday afternoons at the Granary, when anyone could battle them if they thought they were up to it. People would get up and try but for me and Alistair and 3D (even though 3D was established already), the scene was predominately black so it was quite difficult. I remember it now, standing on the stage at the Granary as soon as they saw us, people started to boo! But by the time we'd finished people were 'bigging' us up. That was probably the best thing that happened to me and Alistair at the time. I also remember battling a crew called the Juice, it was a close thing but what tipped it in our favour was when Andrew [The General] cut up 'We got the Juice' and that killed it, the crowd went crazy!

For me and Alistair we became immersed in the black culture of Bristol

"Bristol back then was quite mixed racially in terms of the underground scene"

because of the music, and it was a steep learning curve even though we had black friends and white friends this was an underground thing and to be respected was hard, you had to have skills. I mean, we had Andrew and Delroy literally babysitting us, taking us to places and making sure we were cool and not getting too much grief, after a while people just accepted us not as white boys or whatever but as MCs.

My typical day back then was: wake up mid afternoon, phone Alistair make sure he's about and arrange to link up at Sefton Park Youth Club where Andrew and Delroy worked. That was our HQ. We'd get there about 4pm and hang out, go back home to get food or whatever, go back to Sefton Park, then out to whatever party was going on. Because we were performing at venues in Bristol at the time we got into most places free which was cool.

I went to school with 3D and we were really close but when we started a crew after them, we lost touch. It was really competitive back then, I remember trying to get into the famous Wild Bunch Arnolfini and Demolition Ballroom (Picton Street, Montpelier) parties and them not wanting to let us in! But me and Alistair went to the Wild Bunch and Newtrament jam at the Redhouse and this was a defining moment for us. When we saw Milo and Nellee on the decks and 3D on the mic we realised we were a miles away from that level. So after that we worked at it hard, practising every day to get to a certain level. We're good friends now and still have a laugh about it because it's quite funny when you look back. I think that competition between crews was good, it made everyone get better.

You got to remember Bristol back then was quite mixed racially in terms of the underground scene, so sometimes we'd forget ourselves when we were in another city like London where the underground scene was more predominantly black.

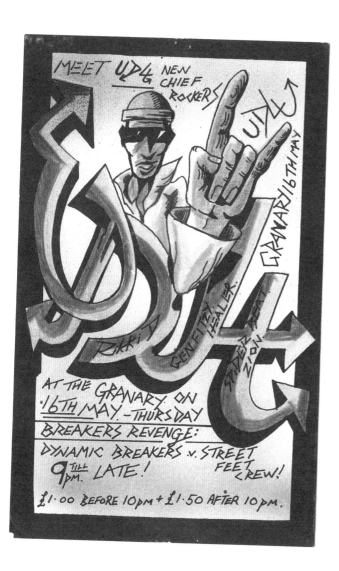

UD4

"Jackin the Groove"

10·00 pm till late

Saturday 28th February

admission £2·00

Opposite the Inkerman Public House Grosvenor Road

Page 111: Family Affair by FLX

Left: KC Rock meets UD4 at Sunset Rendezvous by Krissy Kriss, 1986

Above: The New Chief Rockers, UD4 at the Granary

Right: UD4 at Sunset Rendezvous, 1987

People would look at us two white guys like 'Who the fuck are you!' or 'Who let you in!'

In Bristol I could turn up at a party and get on the mic, it didn't matter if it was a City Rockas party or an FBI party, MCs were in short supply. There was us two, 3D, Willee Wee, Krissy Kriss, Tricky and I mustn't forget Jam Crusher. I remember having some great nights at Dingys behind Frontline Video in St Paul's; we tore it up most times we played there! But I always thought that we could give the Wild Bunch a run for their money, I'm not saying we could beat them, but we could've given them a good test. Even though the Dug Out was Wild Bunch's 'unofficial' club, we DJed there sometimes, I remember one night I was in the DJ booth and wrote 'UD4 The New Chief Rockers' on the wall, I mean we were young, fearless and didn't give a fuck. I turned round and DJ Nellee was standing there and he just smiled and shook his head like 'No Chance!'

The first UD4 party was at the Granary in 1984 and we did our last parties and broke up in 1988. But in those years we'd already done a lot of things around the country, playing in Nottingham, Cardiff and London, and trust me we felt privileged to be a part of this thing. We'd just have a drink, have a smoke or whatever and just go out and do our thing on the mic, we never really thought about it. One time we did a party with the City Rockas at the Mayfair rooms, there were more than 500 people in there and we made £100 between us! Good friends of ours were doing the door for us and they said they just couldn't charge most people to come in because they knew them. So I started to do the doors at our parties sometimes – it had its pros and its cons and I'll leave it at that. When I got into the promotion side of it I saw a different aspect to it, a more businesslike aspect.

> ## "I remember going into a studio and making a three track dub plate and getting them cut in London"

When the crew started to disband and fragment in around 1988 I started to get into promoting, I put on Jungle Brothers, KRS One, Queen Latifah, Just Ice at the Bierkeller and Original Concept as 'Disgize Promotions'. It's funny because at the time we didn't tell anybody we were putting it on! Here's an example: I phoned Prime Time Crew and put on a London accent asking them if they want to play with Jungle Brothers... for free! They were well up for it! But it wasn't until they were actually up on the stage playing that night they realised it was me! I had friends who I fell out with when they found out I was behind 'Disgize Promotions'.

In a way I wish our technology now existed back then, I mean we could've cut all of our stuff onto CD. I remember going into a studio and making a three-track dubplate and getting them cut in London.

I remember thinking; 'yeah we're here and ready to test anyone out there!' It was just awesome coming home and playing it. Now there's so much technology, record companies don't need to invest as much time or money in artists, so in a way it's harder to make it now.

Even though hip hop has become mainstream and global, there's still some underground American and British stuff, but you've got to search a little deeper to find it. But in my

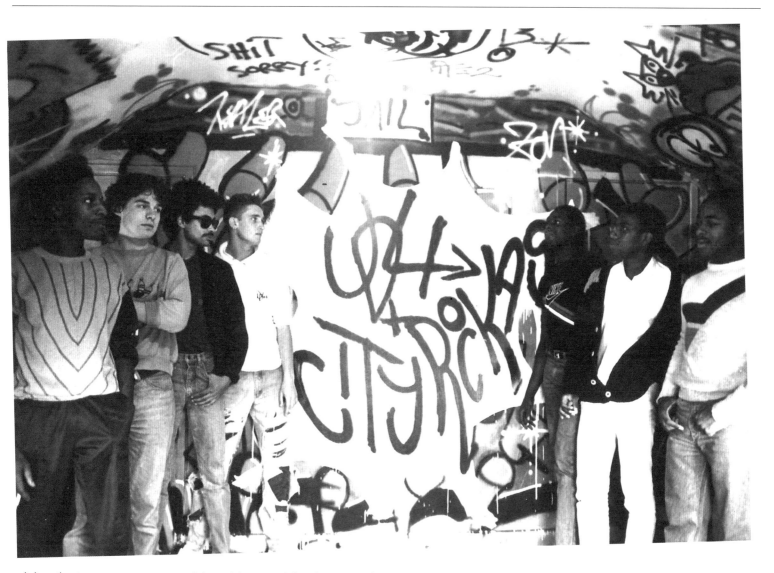

opinion the two greatest crews of the mid Eighties were Tuff Crew and the Ultramagnetic MCs.

Putting on parties back then, if you look back now, seems hard to do with no mobile phones and no internet. But it wasn't, it was just what we did, we didn't really think about it, it just happened. ✖

Left: Disgize Promotions presents Jungle Brothers, True Mathmatics, De La Soul, Mc Gold Top and Prime Time at the Thekla, 1988

Above: UD4 & City Rockas at the Mayfair Rooms, 1985

WISE GUISE

1983 – 1987

CHRISTIAN GEAKE
JASON GEAKE / STEVE PANG

Wise Guise were closely affiliated with Plus One and were one of the first crews to experiment with three deck mixing. They were mainly associated with underground warehouses and illegal house parties

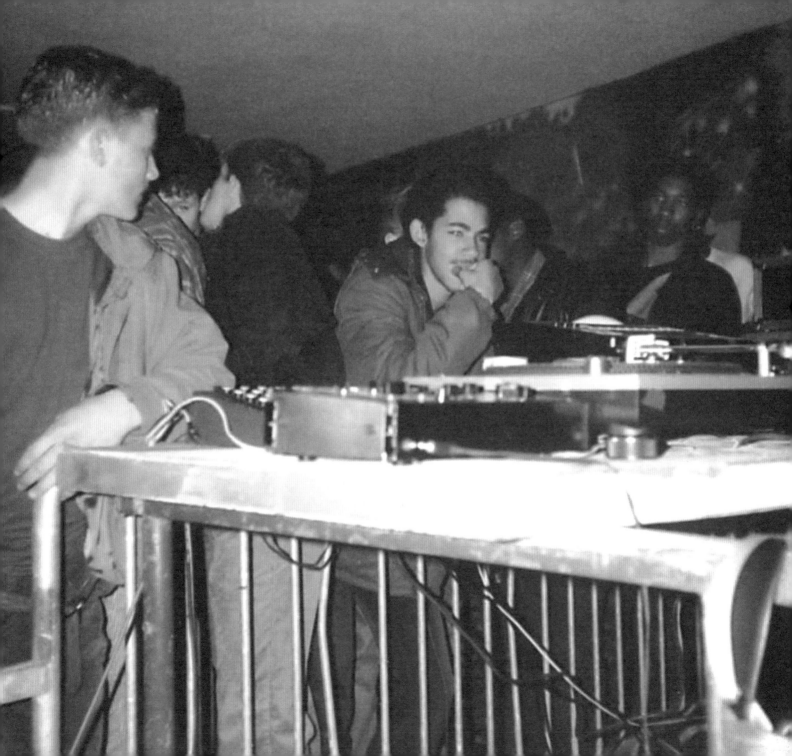

CHRISTIAN GEAKE

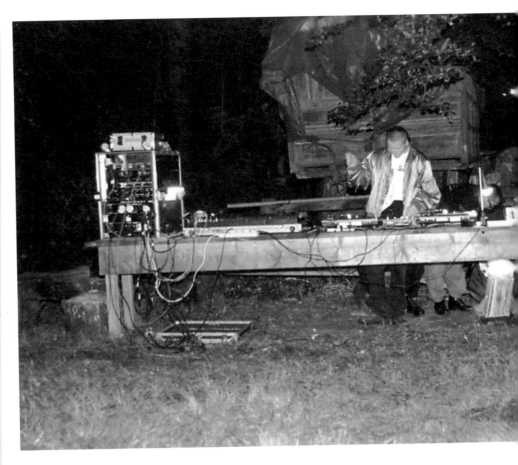

" I remember when we did our first parties, Wilks used to put his gold down as security for the drinks at the wholesalers. We'd get the drinks on a sale or return basis, and only when we returned with drinks and cash would Wilks get his gold back – they trusted him. We'd go to London to buy fresh import 12-inches that you couldn't get here in Bristol, so when we did a party we tried to play tunes most people hadn't heard before.

You could only get hip hop and house imports at shops like Revolver and later Tony's at the time. We were buying red label Def Jam records such as LL Cool J **I Need a Beat** and **Rock the Bells** – always two copies. We even pressed up some Wild Style instrumental bootlegs which were like the holy grail of tunes back then. We took them to some record shops to sell, they were interested but said if we hadn't put the stamp 'Bootleg' on the label they would've taken them, maybe we were a bit naïve.

The first real jam I remember Wise Guise doing was with Wilks and Roni Size [Plus One] behind Frontline Video in St Paul's in 1986, Inkie and Felix did the flyer for it and put up some pieces on the walls inside the venue. This jam was with

a sound system called Sweet Beat from London, we did a 'sound clash' with them. They would play for around 40 mins then we would play. This was the first time I DJed at a party and practised my 'Transformer' scratch for weeks leading up to this.

The reason we did a party at Styx on Ashley Road, Montpelier was that we originally hired a church in Redland but

the place got burned down. Then in our disappointment we were walking down Ashley Road and saw this derelict building (Styx), we broke into it and realised it would be a wicked venue. We cleared everything out, I think Crime Inc came and put some pieces up on the walls. My girlfriend at the time lived on Picton Street, to get power I convinced her to let me plug into her dad's garage. The power

Silver Surfer Productions

present

Wize Guise Plus One

"KEEPING BUSY"

At The Wharehouse

Sat July 11th A.T.7. Starts Late

Pure Theft £2

Crashers Will Be Disposed Of !

Previous page 117: Party people at Dingys, 1986

Far left: Jason Geake at an open air jam

Left: Wise Guise and Plus One at the Warehouse Redcliffe Way, 1987

Above: Wise Guise and Plus One at Styx, 1987

cable snaked along all the rooftops of other people's houses reaching to our venue. I remember her dad kept unplugging it during the party and us having to go over and beg him to turn it back on!

The next time we did a party at Styx with FBI Crew, we had learned our lessons and were a lot more organised. We got my dad to control the door and hired a

"Wilks used to put his gold down as security for the drinks at the wholesalers..."

reliable sound system from one of the old dreads in St Paul's who would control the system for us; all we had to do was make sure he had free beers and a nice bag of

weed! The mic was usually in the hands of Krissy Kriss (Z Rock/3PM) or Alistair (UD4) and we used a drum machine as well as three decks as that was our style. I remember this was the time we were first playing house music imports on Trax Records – Larry Heard's (as Fingers Inc.) **Can You Feel It?** and **Washing Machine** – this must have been about 1986.

The biggest party we ever did was at

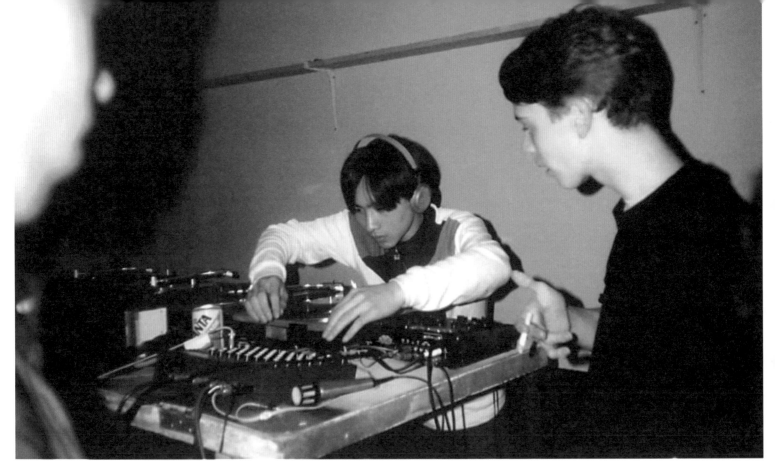

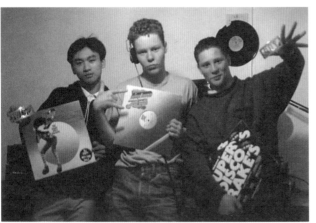

> "We did parties
> in St Paul's or
> Montpellier where
> the police would
> normally leave
> you alone"

Above: Steve Pang on the decks with FLX looking over at Dingys, 1986

Left: Wise Guise, Steve Pang, Jason Geake, Christian Geake, 1986

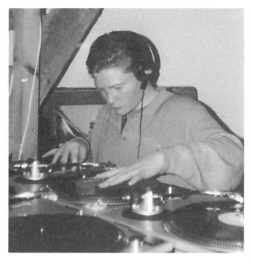

"We got my dad to control the door and hired a reliable sound system from one of the old dreads in St Paul's"

the Warehouse near St Mary Redcliffe. We hired a 4K rig and at the time it was the biggest set of speakers I ever saw! We stocked the bar and hired a generator. We normally did parties in St Paul's or Montpelier where the police would normally leave you alone. But at this party the police were on our case! Jason (my brother) had just been on the TV programme **Why Don't You** and had some letters from the BBC. He cut and pasted the top of a letter (and basically forged it) for it to say we had permission for the party from the BBC. We showed the police this letter the first time they came and they bought it and went away. But then they came back and after much argument, confiscated the starting handle of the generator. We then went and borrowed some power from the Coliseum nearby with our extra long extension lead and carried on. But the police came back and this time they meant business, they shut everything down and that was that! ✖

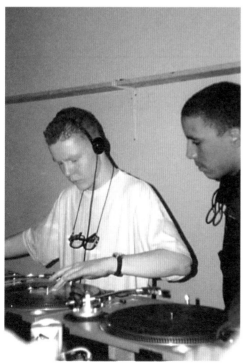

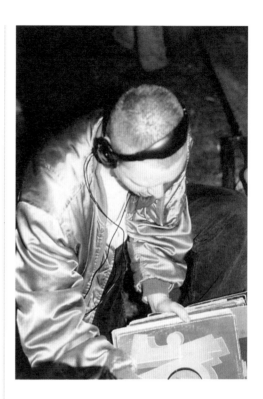

Above left: Christian Geake at home on the decks, circa 1985

Below left: Jason Geake on the deck with Wilks looking over, Dingys 1986

Above: Jason Geake looking through tunes

ING STAR
ES

RINBOHEMIANS
S
JUJU GANITS
R OF HANDS
C.C.Q.

NK & CANATELLA

ATISHEAD
F BARROW
GIBBONS
AN UTELY
McDONALD
SMITH (on live show)
WARA (on live show)
BAGOTT (on live show)
E DERMER (on live show)

EARTHLING

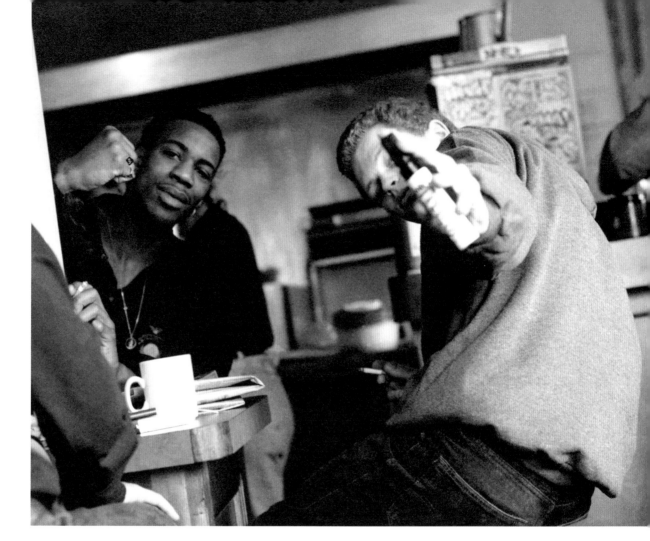

Left: Six Degrees of
Separation, Bristol's
underground family tree
by Naoki E-jima

Above: Krissy Kriss and Nick
Walker at Special K's cafe in
1988

ART & SOUND

OF THE BRISTOL UNDERGROUND